THE ART OF PIETY

THE ART OF PIETY

The Visual Culture of
Welsh Nonconformity

JOHN HARVEY

CARDIFF
UNIVERSITY OF WALES PRESS
1995

A catalogue record for this book is available from the British Library.

ISBN 0-7083-1298-5

Cover illustrations:

*Centre: Christmas Evans (c.*1840), Staffordshire ware.
Reproduced by permission of the National Museum of Wales
(Welsh Folk Museum). Photograph by Robert Greetham.

Background: Rehoboth Sunday School banner, Tre Taliesin, Cardiganshire.
Photograph by John Thomas. Reproduced by permission of the
National Library of Wales.

Cover design by Olwen Fowler, Pentan Design Practice

Typeset at the University of Wales Press
Printed by Henry Ling Limited, The Dorset Press, Dorchester

To the memory of my parents

Contents

Acknowledgements

In bringing together art and Welsh Nonconformity I am grateful for the assistance of the staff of the National Library of Wales and the National Museum of Wales; Michael Freeman, Curator of the Ceredigion Museum, Aberystwyth; Professor Anthony Jones, Rector of the Royal College of Art, London; and Wil Petherbridge of the University of Wales, Aberystwyth for translating Welsh texts. I would also like to acknowledge the financial assistance I have received from the Catherine and Lady Grace James Foundation (Pantyfedwen Trust), the Sir Ben Bowen Thomas Fund, the Sir David Hughes Parry Award, and the University of Wales, Aberystwyth.

Acknowledgement for permission to reproduce artefacts is due to the National Library of Wales for nos. 1, 2, 4, 5, 6, 7, 9, 10, 11, 12, 13, 14, 15, 16, 17, 21, 22, 23, 24, 27, 28, 29, 31, 32, 36, 38, 39, 40, 41, 42, 43, and 44, and for Plates 6, 9, 10, 14, 15, and 16; the National Museum of Wales for Plate 12; the National Museum of Wales (Welsh Folk Museum) for front cover and nos. 19, 20, 30, 33, and 35, and for Plates 3 and 7; the Ceredigion Museum, Aberystwyth for no. 18, and for Plates 5 and 13; the Calvinistic Methodist Historical Society for nos. 3 and 34, and for Plate 4; Bethel Welsh Baptist Chapel, Aberystwyth for Plate 1; Siloh Presbyterian Church of Wales, Aberystwyth for Plate 2; Professor Anthony Jones, London for no. 8; and the Reverend Geoffrey and Mrs Iola Thomas, Aberystwyth for Plate 8.

Photographic credits are due to the National Library of Wales for nos. 1, 3, 4, 5, 6, 9, 10, 11, 12, 13, 14, 15, 16, 17, 21, 22, 23, 24, 27, 28, 29, 31, 32, 34, 36, 38, 39, 40, 41, 42, 43, and 44, and for Plates 4, 6, 9, 10, 14, 15, and 16; the National Museum of Wales, Cardiff for Plate 12; the National Museum of Wales (Welsh Folk Museum) for no. 20 and Plate 3; Robert Greetham for front cover and nos. 18, 30, 33, 35, and for Plates 1, 2, 5, 8, and 13; Jacqueline Harvey for nos. 19, 25, and 26, and Plates 7 and 11; and Professor Anthony Jones for no. 8.

Introduction

Nonconformity has actually retarded the development of some of the finest elements in the Welsh character. It has dulled its artistic sense, and its innate gift of idealisation . . . Nonconformity has no genuine conception of architectural art, and all the elaborations of art in religion have been considered as out of keeping with the simplicity of religion. The symbolism of worship is a thing entirely foreign to the Nonconformist mind, and all artistic accessories to worship are regarded as relics of idolatry. What love of art there is, what dramatic instinct, what aesthetic taste there is, exists in spite of Nonconformity.

Viator Cambrensis, *The Rise and Decline of Welsh Nonconformity*[1]

It has been a popular belief that Nonconformity opposed the use of all forms of visual art in religion, in accordance with the Reformation doctrine forbidding the use of images in worship. This was, according to some writers at the beginning of the century, apparent in the exclusion of symbolism and artistic elaborations from religious life and a distrust of art in general. It has further been suggested that this outlook had stifled an enthusiasm for art and aesthetic taste in the character of the Welsh people. There is, however, evidence to the contrary; for while Nonconformity opposed the use of art as a means of worship, it did not repudiate it as a handmaid to religion. The proof lies in the various types of artefacts used by Nonconformists to meet the requirements of decoration, commemoration, and education, and the positive contribution individual Nonconformists made to the visual culture of Wales around the beginning of the twentieth century.

Nonconformity's visual expression would have been difficult to see unless one frequented Nonconformists' chapels, homes, and educational establishments. The decorative and pictorial artefacts which were common in the chapels from the mid-nineteenth to the early twentieth centuries included stained-glass windows, stencilled motifs of plant forms, and paintings of unfurled scrolls bearing texts from the Bible. Embedded in the chapel walls were ornate memorial plaques to departed ministers and faithful members of the congregation. By the middle of the twentieth century, plaques honouring the dead of the two world wars would be added. Other artefacts, less intimately attached to the building's fabric, included photographs and painted portraits of ministers, framed prints of paintings relating to the sacraments, and colourful Sunday School banners.

The assumption that Nonconformity had no 'elaborations of art in religion' loses credence further when one enumerates the many and varied visual artefacts used in education and domestic decoration. With the revolution in printing and publishing

facilities and the growth of religious education, nineteenth-century Wales saw an increase in Nonconformist literature. This was in the form of Bibles, religious books, periodicals, and newspapers; posters and cards were printed as teaching aids for the very young, together with certificates of merit for outstanding Sunday School scholars. Many of these were illustrated with lithographs, and steel-plate and mezzotint engravings in the early part of the nineteenth century, together with photographs in the latter part of the century. The images depicted a wide range of subjects, such as scenes and characters from the Bible, prominent Nonconformist preachers, famous preaching meetings, chapels and chapel life, and a variety of representations from the natural world, including flowers, animals, and country landscapes. Similar images found their way on to the walls of Nonconformist homes. Illustrations in books became decorations in the domestic context, and were hung beside embroidered Bible texts and pictures of biblical characters and events.

Although it cannot be claimed that paintings and sculptures ever formed an integral part of Nonconformist worship, they did have a place in the lives of the congregations. The progress of the industrial revolution and the establishment of Nonconformity gave rise to a new middle class in Wales, and provided a source of patronage for local portrait painters. Among their subjects were the notable occupants of the Welsh pulpits, whose portraits found their way into not only their own houses, but also those of God. The likenesses of ministers were also captured in memorial statues installed in the denominations' colleges of theology and chapel grounds. Art, therefore, found acceptance not as an instrument of worship, but as a means of commemoration.

Over the years, many of the artefacts have been lost through deterioration of age, and through wilful neglect and destruction. This is not necessarily an indication of Nonconformity's indifference to art, for what we today may consider as being of sociological and art-historical importance were in their own time regarded as ephemera and of no great value beyond their use. The National Museum of Wales's Yr Hen Gapel outstation at Tre'r-ddôl, Dyfed, and the National Library of Wales's Calvinistic Methodist Archives have ensured the preservation of many examples of these artefacts. With an increasing number of chapels facing demolition, however, the decorations painted on their walls will disappear for ever. Changes in the congregations' taste, the preference for less elaborate interiors, have also effected their destruction. Many have already been painted out in favour of bland walls of pastel emulsion. It is therefore imperative that an examination of these things begins before it is too late.

Accordingly, this book constitutes a descriptive survey of these artefacts and the particular spheres in which they were called to serve: the chapel, the home, decoration, commemoration, and teaching. Many of the artefacts incorporate images. In the light of Reformation doctrine this observation is of some significance; therefore the visual expression of Nonconformity has been checked against the tenets of its doctrine throughout. The final chapter examines the accusation that Nonconformity was to blame for the poor state of visual art in

Wales; it describes concomitant conditions that brought this about, and how certain Nonconformists sought to put right this failure. In the context of the book, the term 'art' refers to the fine, graphic, decorative, and applied arts, while 'Nonconformity' refers to Welsh Nonconformity (unless otherwise stated) and embraces the groups called Baptists, Wesleyan Methodists, Calvinistic Methodists or the Presbyterian Church of Wales (the two terms refer to the same group in Wales), and Congregationalists or Independents (which terms are also used interchangeably).

Nonconformity was among the most powerful forces acting upon nineteenth- and early-twentieth-century Wales. It was certainly the most pervasive, influencing not only its spiritual dimension but also its political thought, its educational and social structures, and its culture. A thorough understanding of that culture's visual expression cannot be said to exist without reference to the Nonconformist movement. It is the purpose of this book to make a contribution to the growing body of work seeking to rectify this deficiency.

1

Art in the Service of the Chapel

The Puritan movement which followed in the wake of the Calvinistic Reformation fell into the very serious error of excluding man's natural homage to Beauty from Religious life . . . Go through this land of Wales and look at the Soars, Shilohs, Tabernacles and Ebenezers scattered upon the fair hill-sides. You are tempted at once to quote.

> . . . 'Every prospect pleases
> And only man is vile'.

Devoid of architectural or artistic merit the so-called 'places of worship' are blots upon the landscape. Within they are innocent of any uplifting atmosphere and would foster the idea that the God for whose service they are erected takes pleasure in meanness, cheapness and ugliness for their own sake.

Edmund Tyrrell-Green, *Art and Religion*[1]

Like their Puritan ancestors, Nonconformists have been popularly caricatured as people of extreme austerity in worship, who rigorously denied pleasure to their senses, and were ready to pluck out both eyes in the cause of piety. It has been assumed that they renounced aesthetics in favour of asceticism, and that this led to a complete exclusion of art from the chapels. However, the prejudiced view that the chapels were devoid of architectural merit has been roundly challenged more recently. According to Anthony Jones, the chapels are 'without question, the national architecture of Wales'.[2] He regards the absence of a particular style, the simplicity of their design, and their functionalism as a visual expression of Nonconformist ideals. The visual appeal of the chapels has been noted by many landscape painters of Wales, whose often celebratory images of their resplendent façades have shown that, far from being blots on the landscape, the chapels are one of the most distinguishing aspects of it.

But what of the chapels' interiors? Did the attitude of the Calvinistic Reformation to beauty and religious life, and in particular its prohibition on the use of images in worship, turn Nonconformist places of worship into an artistic vacuum, as it has been supposed? To answer this question, one needs to look, first, at what Calvinism prescribed regarding the relationship between art and religion and, secondly, at the chapels themselves.

Calvin and Art

The teachings of Nonconformity followed those of the Reformation in the sixteenth century, which sought to rid the Church of all extraneous traditions that had grown up under Roman Catholicism, to reassert the Bible as the only authority in matters of personal conduct and worship, and to reject any practice that was not taught therein. The most comprehensive and systematic statement of Reformation belief is to be found in the work of the French theologian John Calvin (1509–64). In his *Institutes of the Christian Religion* of 1536 he discussed the nature of art and its use in a place of worship.

Calvin based his argument on the injunction of the second commandment: 'Thou shalt not make unto thee any graven image, or any likeness of any thing that is in heaven above, or that is in the earth beneath, or that is in the water under the earth: thou shalt not bow down thyself to them, nor serve them' (Exodus 20:4–5a). 'By these words', he reasoned, God 'curbs any licentious attempt we might make to represent him by a visible shape . . . he rejects, without exception, all shapes and pictures, and other symbols by which the superstitious imagine they can bring him near them.'[3] Calvin condemned all attempts at a visual representation of God as impious lies, for even the most magnificent work of art could never adequately express the full grandeur of His majesty, and could serve only to belittle man's conception of Him. He used this argument to refute the Roman Catholic Church's belief that images were a means by which the illiterate could know something of God. 'Everything respecting God which is learned from images' was, in Calvin's view, 'futile and false.'[4] It was not through images of God or of holy persons that Christians should be taught in places of worship, but rather through 'preaching of the Word and the administration of the sacraments'.[5]

The setting up of icons, that is images of holy persons such as Christ, the virgin Mary, and the saints, had been a controversial issue in the Church before the Reformation. Decrees had been passed by emperors and church councils approving their use, only to be later countermanded by the decrees of their successors. In the end, the controversy was settled in favour of icons. During the periods when icons were permitted, images of holy persons found their way on to church walls, holy vessels, and vestments, into pictures and homes, and were set up by roadsides. These images were intended to arouse in the believer a recollection of and a longing after the persons represented, and to encourage their veneration and worship. As the proclamation of the Second Council of Nicaea explained in AD 787: 'the honour paid to the image passes to its original, and he that adores an image adores in it the person depicted thereby.'[6]

Calvin saw the dangers of such practices, for the history of the Church had shown that when images were set up as an aid to devotion they often became the subjects of idolatry; adoration often did not go beyond the images. He was at pains to point out that his censure of such images was not a blanket condemnation of art. On the

contrary, he believed that painting and sculpture were gifts from God, to be used in accordance with what was biblically permissible, for God's glory and for man's good. Since it was unbiblical to make a visible representation of God, 'the only things, therefore which ought to be painted or sculptured, are those things which can be presented to the eye'.[7] Calvin divided permissible representations into two classes, 'historical, which gives a representation of events, and pictorial, which merely exhibits bodily shapes and figures'.[8] The second class included images of prophets, saints, and martyrs. The former he considered useful for teaching, the latter, which were most commonly found in churches, fit only for 'amusement' – they were neither decent representations of holy persons nor depictions of biblical history, and were therefore of no use in teaching.[9]

The legitimacy of making 'historical' and 'pictorial' representations was one matter; whether it was expedient for churches to contain them was another. According to Calvin, the Christian Church was for the first 500 years of its life completely free from visual representations. The early Church Fathers had also regarded them as a means of encouraging superstitious worship. Images were first admitted into the Church when the purity of its doctrine began to decline. It is not surprising that Calvin, in his desire to bring about doctrinal reform, suggested that all images be excluded from Christian places of worship: 'When I consider the proper end for which the churches are erected, it appears to me more unbecoming their sacredness than I well can tell, to admit any other images than those living symbols which the Lord has consecrated by his own word: I mean Baptism and the Lord's Supper, with the other ceremonies.'[10] He similarly equated theological declension with the introduction of 'Ornament' into the Church, by which he may have been referring to the accessories or furnishings of the church and worship, for example chalices, vestments, books, and beautifying embellishments such as decorative painting and carving.[11]

Ornament: Furnishings and Liturgical Artefacts

Calvin, as E. T. Davies has remarked, was 'the theological father of British Nonconformity'.[12] His ideal that churches be simple and unadorned is fulfilled by the conventicles used by the Dissenters in the seventeenth century and the meeting-places of Nonconformists in the eighteenth century; the latter, complained the Welsh religious historian Thomas Rees (1815–85), were plain and unsightly barns with no architectural taste or ornament.[13] The bareness of the meeting-places or 'barn-chapels', like that of the Puritan conventicles, reflected not only the congregations' theological purity but also their domestic interiors.[14] It is likely that the austerity of chapel and home was due as much to the congregations' poverty as to their distrust of beauty. Ornament was first introduced into chapel interiors during the golden age of chapel-building inaugurated by the religious revival of 1859. During the next forty years the architectural forms and fittings became more

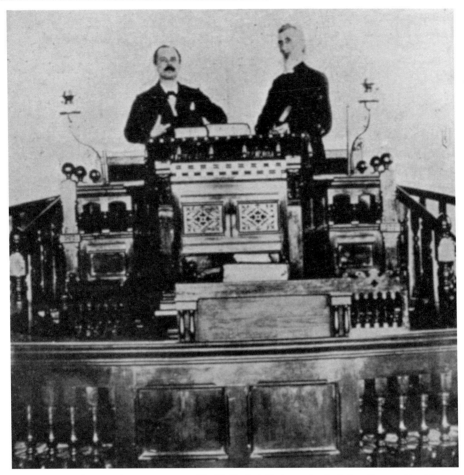

1 Pulpit (nineteenth century, second half), Bethel (Independent), Arfon, Caernarfonshire,
photograph probably by John Thomas.

elaborate and their craftsmanship more conspicuous. Professional architects,
together with joiners, carpenters, wrought-iron workers, and stained-glass-window
companies were enlisted to design the buildings. But, as Rees recorded, this
transition did not occur without resistance:

it was no easy matter to persuade the descendants of people who had been
compelled for generations to worship God in caves, barns, and obscure cottages,
that neat and costly places of worship were necessary and becoming. The least
architectural ornament – pews instead of bare benches, and even brass chandeliers
instead of clumsy iron candlesticks, the workmanship of the village blacksmith –
were regarded by many as sinful innovations and signs of pride, unbecoming the
humble worshippers of God. Those good people never called to mind the fact that
the plan of the first place of worship erected on this earth came direct from heaven,

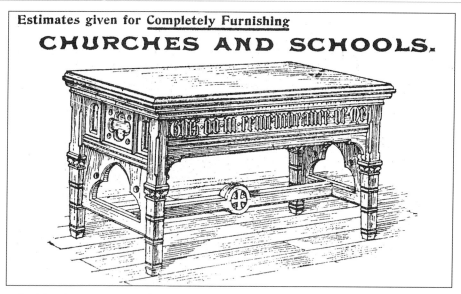

2 Advertisement: communion table (twentieth century, first quarter), supplied by Geo. M.
Hammer and Co., church and school furnishers (London).

and that the structure constructed in accordance to it was a very costly one. Those
generations of mistaken Christians have passed away, and have been succeeded by a
generation of more expanded ideas and a greater sense of propriety.[15]

The elaboration of the chapels and their interiors was motivated by the
considerable exposure given to the decorative arts by the Great Exhibition of 1851,
and by the development of a better economic climate in Wales and of a Welsh-
speaking middle class, which meant wealthier congregations.[16] Denominational and
inter-church rivalry also provided a fillip. The Baptist minister C. H. Spurgeon
(1834–92) believed that there was a danger that the competitive spirit would
degenerate into bitterness and envy, and that congregations would mistakenly
correlate the material splendour of their buildings with spiritual prosperity and
prowess.[17] The opulence of some chapels would have had more than a passing
resemblance to the splendour of 'the first place of worship' built by the Israelites in
the wilderness. Nonconformists actively cultivated the association in other ways. A
chapel was often referred to as the 'sanctuary', 'temple', or 'house of God' (Hebrew
Beth-El), signifying its figurative relation to Jewish places of worship. The opening of
a new chapel, as recorded in the histories of the buildings and their congregations, is
often described in terms reminiscent of the dedication of Solomon's Temple or the
inauguration of the Tabernacle (1 Kings 8; Exodus 33).[18]

Calvin's prohibition of the use of images meant that the communal worship of
Nonconformity could be carried out only through literary, oral, and musical forms,
that is through the teaching and reading of the Bible, prayer, and the singing of
psalms and hymns. The only visual aids he permitted for the direct expression

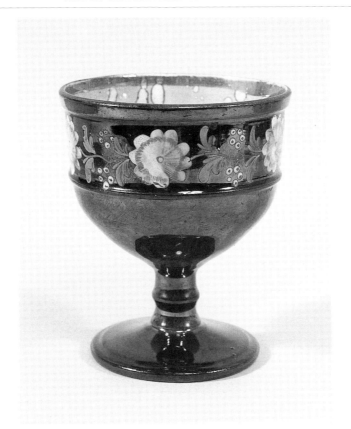

3 Communion cup (eighteenth century, first quarter), copper
lustre with enamel motif, probably Staffordshire ware, Maengwyn,
Machynlleth.

of worship were those ordained in the sacraments. Baptism and the Lord's Supper
were represented by the symbols of water, and of bread and wine. The symbol of
the cross was rarely seen and never venerated. The crucifix, a representation of the
cross with the figure of Christ crucified on it, was never used, as it would have had
too strong an association with popish practices.

While it jettisoned certain Roman Catholic symbols, Reformation doctrine also
generated a number of its own. These were expressed through the positioning of the
chapel's essential fittings. The pulpit and communion table provided the visual focus
for the Nonconformist service. The pulpit was situated centrally against the wall
facing the congregation, with the communion table below and in front of it,
symbolizing the centrality of the Word of God and the atoning death of Christ in
the life and worship of the congregation. In the more wealthy chapels the pulpit was
the most prepossessing fitting of the interior. This was not only due to its often
enormous size (it sometimes towered ten to fifteen feet above the congregation), but
also because of its lavish treatment in polished wood, inset with panels bearing
Gothic mouldings and ornamental carvings (1). In this way the pulpit embellished

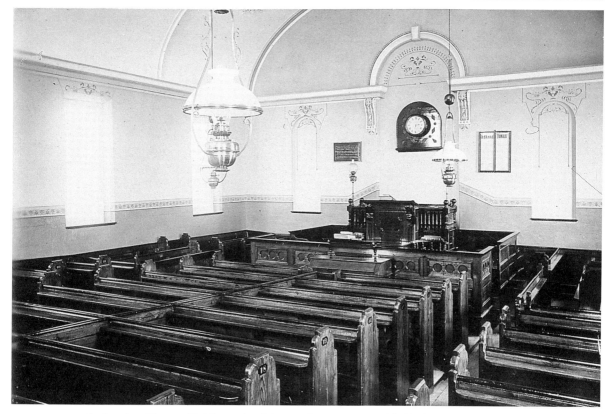

**4 Interior with stencilled decoration (nineteenth century, second half), Cefnddwysarn Chapel
(Calvinistic Methodist), Bala.**

and thereby adorned the Word of God as the illuminated manuscript had done with
colour and calligraphy in the Church of the Middle Ages.

The Nonconformist view of the communion table was, as M. S. Briggs has
written, that it 'should be plain but comely in design not flimsy or overdecorated'.[19]
Anything more elaborate than this would have had associations with the Roman
Catholic altar. For the same reason the table was made of wood rather than stone.
The words Christ spoke at the Last Supper concerning the sacrament – 'This do in
remembrance of me' (Luke 22:19) – were often carved in Gothic letters on the front
of the table (**2**).[20] During the administration of the Lord's Supper, the minister and
deacons would sit around the communion table upon which were the bread and
wine. The minister, seated at the centre of the table, would read aloud the words of
Christ to His disciples at the Last Supper, which symbolically identified him with
Christ. By the same token, it could be argued that the deacons, seated to the left and
right of the minister, symbolized the twelve Apostles. This arrangement provided
Nonconformists with a perhaps unconscious but nevertheless striking tableau vivant
of the Last Supper as represented in Western European religious painting.

Some of the communion cups used by Nonconformists in the eighteenth century

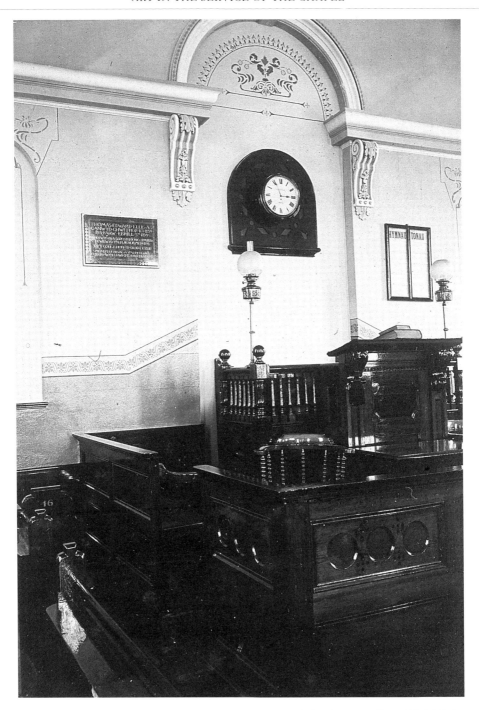

5　Stencilled decoration (nineteenth century, second half), Cefnddwysarn Chapel (Calvinistic Methodist), Bala.

were modestly elaborate in design. There were, for instance, glazed earthenware and copper-lustre cups decorated with brightly coloured floral designs (**3**), and also silver cups and chalices with a delicate lattice-work stem and an appropriate text cut below the circumference of the lip. One example is decorated with two images illustrating faith and hope. The images are similar to those in Protestant emblem books of Francis Quarles (1592–1644), George Wither (1588–1667), and Geffrey Whitney (?1548–?1601), which evangelicals in the eighteenth and early nineteenth centuries were commended to read.[21] The image representing faith shows a woman with a communion cup in one hand and her other arm raised in exhortation. Behind her is an open Bible on top of a small pulpit similar to those used in open-air preaching (the scene is set in a landscape). Together they symbolize the means by which faith is declared – the Word of God and preaching. A cross floats somewhere between her and the pulpit, symbolizing Christ, the object of faith. In raising the communion cup to their lips, participants in the Lord's Supper not only received the sacramental symbol of Christ's blood but also a discreet visual sermon.

Ornament: Wall Decorations

The colour scheme of chapels changed little from the early meeting-houses converted from barns and cottages in the seventeenth century to the eclectic edifices built at the end of the nineteenth century. The interior walls of the early barn-chapels were usually whitewashed; it was commonly believed to be an expression of the Puritan heritage. During the eighteenth and early nineteenth centuries chapels built in the styles of the Greek and Gothic revivals maintained an essentially monochrome colour scheme of white, cream, and grey.[22] The furnishings of the chapel – the pews, pulpit, and organ-case – were uniformly of varnished pine, their heavy and darker tones weighting the lower part of the church and contrasting with the airy pale walls and ceiling (**4**).[23] 'Stencilled borders in gay primary colours at salient points' gave 'cheerful relief to the otherwise severe interior' (**4** and **5**).[24] They were among the few ornaments found in the chapel, which had no other purpose than to adorn. Stencilled borders and designs were to be seen on the chapel's interior walls and on the imposing assembly of organ pipes situated above or to one side of the pulpit (**6** and **7**). During the nineteenth century stencilling was part of the decorator's trade and skill.[25] Since they were contracted for the decoration and painting of the chapels, local decorators were to a large extent responsible for the designs on the walls.[26] Stencil designs were reproduced from patterns in popular books of ornament such as Henry Shaw's *The Encyclopaedia of Ornament* (1836), Owen Jones's *The Grammar of Ornament* (1856), and George Ashdown Audsley and Maurice Ashdown Audsley's *The Practical Decorator and Ornamentist* (1892), and from journals including *Decoration*, *Studio*, and the *Art Journal Illustrated Catalogue*. These would have provided the congregation with a range of options from which to choose an appropriate design for the chapel interior.

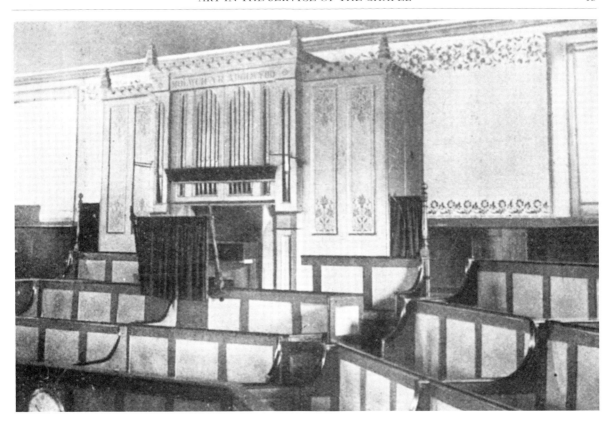

6 Stencilled decoration (nineteenth century, second half), Ebenezer (Calvinistic Methodist),
Newport, Monmouthshire.

7 Stencilled decoration on organ pipes (nineteenth century, last quarter), Somerset Street
(Calvinistic Methodist), Abertillery, Monmouthshire.

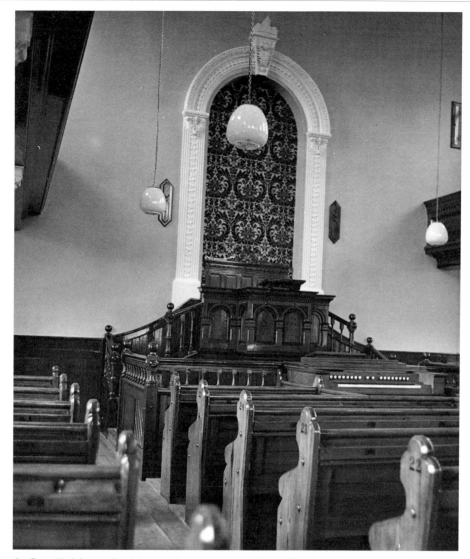

8 **Stencilled decoration (nineteenth century, second half), Horeb (Calvinistic Methodist), Cray, Breconshire.**

The stencil designs chosen were, generally, based on plant forms. A single motif was often repeated along the length of a chapel wall at the eye level of the seated congregation. In other instances they were reproduced to fill a large expanse of wall. There were occasions when the section of wall immediately behind the pulpit was treated in this way, giving a heightened visual focus to the chapel interior (**8**). Kenneth Lindley suggests that this use of stencilling to produce a mass of decoration 'must have owed a great deal of its origins to Victorian typography'.[27] The stencilling was probably considered safe because it had no obvious symbolism, and was derived from God's own handiwork in nature.

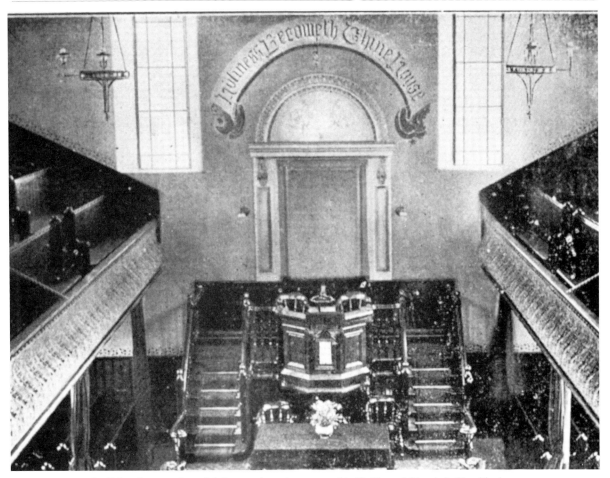

9 Painted text and scroll (nineteenth century, second half), Carmel (Baptist), New Tredegar, Monmouthshire.

The plainness of the walls of the chapels was further broken up by biblical texts which were incorporated into unfurled scrolls or ribbons and painted on the wall above the pulpit or organ pipes. Frederick Scott-Mitchell's *Specifications for Decorators' Work* of 1908 provides notes on the cost and execution of painted texts or lettering, as it was more commonly referred to. The decorator (in many instances, probably the same person commissioned to undertake the stencil decorations) submitted to the client the design for a text in the form of a preliminary sketch, in colour when appropriate, free with the estimate.[28] The painted texts satisfied the demands of a theology that prohibited images in worship and emphasized preaching. The Word declared from the pulpit was also exalted on the chapel wall; what the preacher animated by rhetoric the decorator illumined with bold type, gold, and bright colours. In the absence of representations of Christ, Mary, saints, prophets, and martyrs, the Word of God became an icon (**9**).

The biblical texts chosen for illumination either extolled an attribute of God or

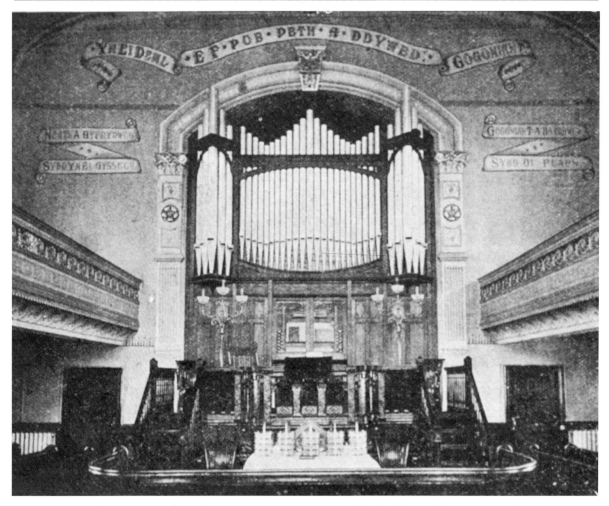

10 Painted text and scroll (nineteenth century, second half), Bethel Newydd (Congregational), Cwmaman, Carmarthenshire.

commended a particular attitude of heart and mind in which to come before Him in worship. The most common example of the former was 'God is love'. (One wonders to what extent it was chosen because it was short and therefore relatively inexpensive to paint.) The exhortations to worship were generally longer and would sometimes span almost the width of the chapel. Where the wall space was limited the use of a convention like painting the scroll criss-crossed enabled the words to be arranged on a diagonal (**10**). In many chapels the relation of the scroll to the architectural features of the main wall was carefully considered. Sometimes the scroll deliberately echoed the contours of the windows, the arch on the wall behind the pulpit, or the recess that enclosed the organ (**11**).

 There are precedents for the integration of lettering with the design of a building in Greek basilicas and Italian Renaissance churches. Scriptural texts were written on

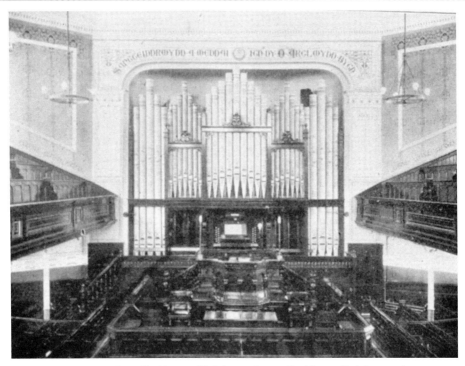

11 Painted text and scroll with stencilled decoration on flanking walls (nineteenth century, second half), Jerusalem (Calvinistic Methodist), Tonypandy, Glamorgan.

the walls of churches by the sixteenth-century English Reformers. At the same time, the convention of the scroll bearing lettering was also widely used in Victorian commercial advertising, and would have been painted by the same decorators who illuminated the chapel interiors. (In this way the decorator served both God and Mammon.) However, the scroll painted on a chapel wall took on biblical associations, for example the scroll or roll in Zechariah 5:1–2: 'Then I turned, and lifted up mine eyes, and looked, and behold a flying roll. And he said unto me, What seest thou? And I answered, I see a flying roll; the length thereof is twenty cubits, and breadth thereof ten cubits.' The scrolls were mediators of the truth and instructors in devotion. To this extent they may justifiably be defined as 'accessories to worship'.[29]

Images

Both kinds of images distinguished by Calvin – the 'historical' and the 'pictorial' – also found their way into the chapels, particularly in stained- and painted-glass windows. In 1904 Pontycymmer Congregational Church in Bridgend, Glamorgan installed what was considered to be one of the finest examples of stained glass to be seen in its denomination's churches (**12**). The contractors were Willis and Jones of London, Birmingham, and Liverpool, manufacturers of church furniture. Their

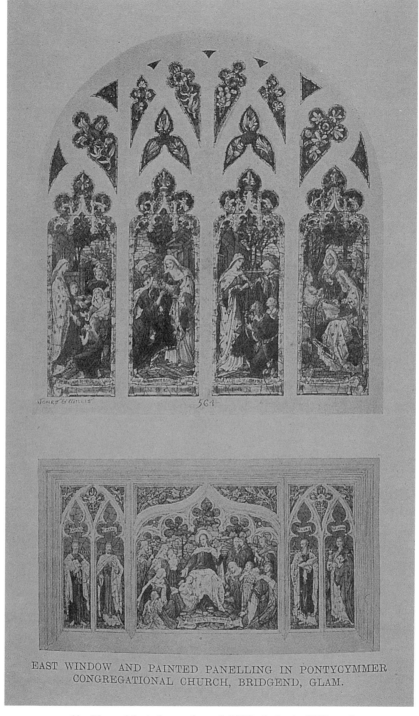

EAST WINDOW AND PAINTED PANELLING IN PONTYCYMMER
CONGREGATIONAL CHURCH, BRIDGEND, GLAM.

12 Memorial window and panel (1904), design by Willis and
Jones, church furnishers (London), Pontycymmer
(Congregational), Bridgend, Glamorgan.

advertisements of trade appeared in Nonconformist yearbooks and magazines and Anglican literature.[30] Companies supplied their wares across the board of churches and rarely discriminated between their different doctrinal positions. Consequently a church like Pontycymmer Congregational could be fitted with a window and painting that would not have looked out of place in a cathedral. A description of the window appeared in the *Congregational Year Book* of 1905:

> The subjects depicted are four of the acts of Mercy, as described by St. Matthew, chap. xxv. In the first light from the left is shown a group which is composed from the text, 'I was an hungered, and ye gave me meat'. In the second light, 'I was thirsty and ye gave me drink'. The text represented in the third light is, 'Naked and ye clothed me', and lastly, 'I was sick and ye visited me'.
>
> The tracery above the lights contains emblematical flowers such as the rose, passion-flower, lily, pomegranate, and in the trefoil, palms and olives, entwined with crowns accompanying.[31]

The window's main lights fit most readily into the category of the historical in Calvin's classification: they are illustrations of biblical teaching, transcending the pictorial rendering of mere 'bodily shapes and figures'.[32] The four scenes depict a disciple tending to the physical needs of the destitute. The representation of the mercies was intended to teach the congregation to do likewise. The images thus had both a didactic and an ornamental purpose. Christ is not portrayed in any of the four scenes, although His presence may be implied in the destitute crowds with whom He identified: 'Inasmuch as ye have done it unto one of the least of these my brethren, ye have done it unto me' (Matthew 25:40).

In the tracery and trefoil there are allusions of a different order to Christ. The emblems of plants, fruits, flowers, and crowns refer symbolically to His person, life, and attributes. The admission of visual symbols to a Nonconformist place of worship is significant, for they are contrary to Calvin's recommendation that only sacramental symbols be allowed in a church. One of the fruits depicted was a pomegranate, a particularly obscure symbol of resurrection derived from the classical myth of Proserpine. This emblem, together with the passion-flower, symbolizing Christ's suffering, originated in the Roman Catholic tradition. The window also depicts a rose, which in Roman Catholicism is considered to be an emblem of love and beauty, and symbolizes the virgin Mary as the 'mystical Rose'.[33] In the context of a Nonconformist chapel and Nonconformist theology, the emblem would have been divested of these overtones, which are peculiar to Roman Catholic dogma. If anything, the rose would have been an innocuous symbol for Christ, derived from the second chapter of the Song of Solomon.

Symbolic representation is used in the Bible, in the parables of Christ, where spiritual realities are represented by physical objects. Christ spoke of Himself as a grape-vine and a shepherd, and of His followers as vine branches and sheep. This kind of symbolism was often drawn upon in the design of chapel windows. Such

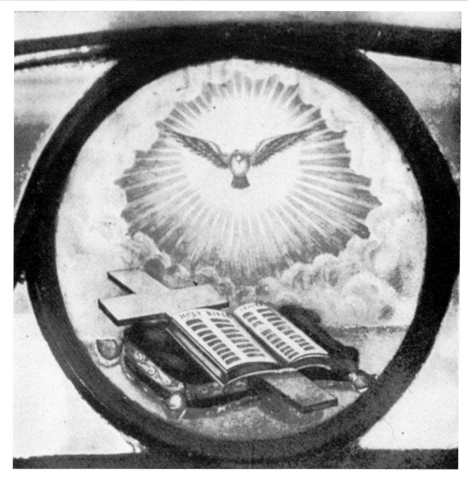

**13 Painted-glass panel, design by Hugh Hughes, Water Street (Calvinistic Methodist),
Carmarthen.**

images permitted visual reference to Christ without transgressing the second
commandment, and were therefore safe. However, some windows depicted Christ
literally, for example at Gilgal Baptist Church, Porthcawl, South Glamorgan. In the
main light is a stained-glass transcription of one of the most celebrated religious
paintings of the nineteenth century, William Holman Hunt's (1827–1910) *Light of the
World* (1854). This would appear to be a serious breach of Calvin's injunction against
the representation of God by visible shape or picture. However, some
Nonconformists may have reasoned that, since Christ was also man, the prohibition
of the second commandment did not apply to these images.

Symbolic representation is also found in the painted glass in both the doors
leading into Water Street Calvinistic Methodist Chapel in Carmarthen (**13**). The
image, according to tradition, is the origin of the Connexional emblem adopted by
the General Assembly of the Calvinistic Methodist Church in 1885.[34] It was
designed, and probably painted, by the artist Hugh Hughes (1790–1863), one of the

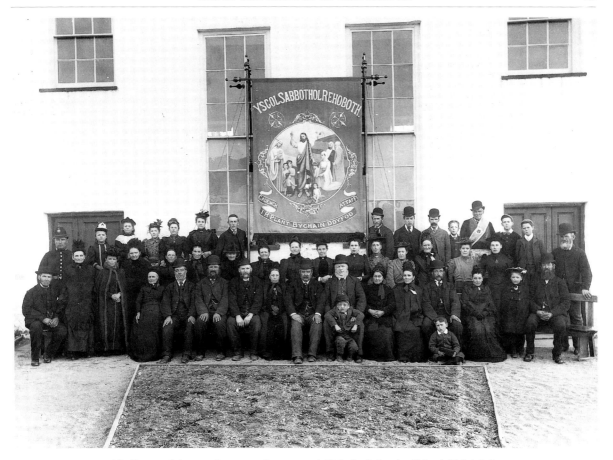

14 Banner (nineteenth century, last quarter), Rehoboth Sunday School (Calvinistic Methodist), Tre Taliesin, Cardiganshire, photograph by John Thomas.

most notable Welsh portrait painters during the nineteenth century. The cross symbolizes Christ and salvation, the Bible the means by which that salvation is communicated to men, and the dove the Holy Spirit, who inspired the Bible and convinces men and women of the truth. The image of the dove is a clear departure from Calvin's injunction that the Holy Spirit not be given a visible form. At Christ's baptism, he argued, 'The Holy Spirit appeared under the form of a dove, but as it instantly vanished, who does not see that in this symbol of a moment, the faithful were admonished to regard the Spirit as invisible, to be contented with his power and grace, and not call for any external figure?'[35]

Images of saints also found their way into a number of chapel windows, as both historical and pictorial representations. For example, in 1908 Jerusalem Calvinistic Methodist Church in Tonypandy, Glamorgan installed a memorial window in its lobby which depicts Paul preaching to the Epicurean and Stoic philosophers at the Areopagus in Athens (Acts 17). Many of the representational windows were installed in the façade wall of the chapels, which meant that they would not be seen during a

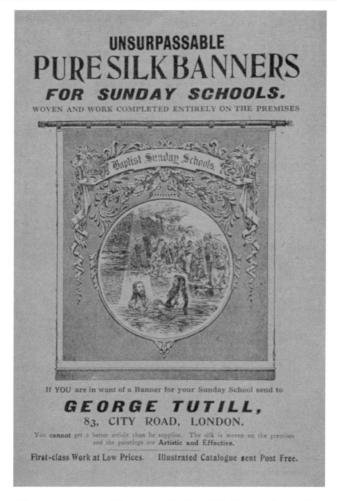

15 Advertisement: 'Unsurpassable Pure Silk Banners for Sunday
Schools' (1917), George Tutill (London).

service, for the congregation would be facing away from them towards the pulpit. Thus, while they were a means of teaching and ornamentation, they did not encroach on the congregation's worship as a distraction or accessory. Whether this was a conscious solution to the problem of using representational imagery it is difficult to tell. There were instances of windows that were installed behind the pulpit, although these tended to contain purely decorative arrangements of coloured glass. Similar windows, or ones made of painted glass and ornamented with plant forms, were often set in the partition wall between the vestibule and the 'sanctuary', or main meeting-room. The example illustrated is found in the vestibule of Bethel Welsh Baptist Chapel, Aberystwyth and was made by Swaine Bourne of Birmingham (**Plate 1**).

Next to stained- and painted-glass windows, Sunday School banners were the

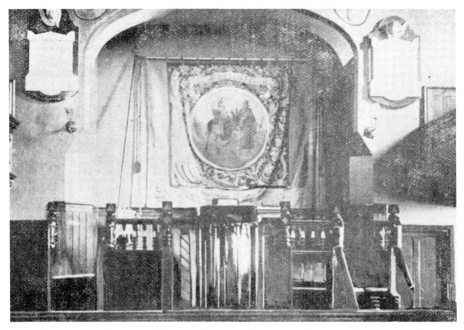

16 Banner behind pulpit (twentieth century, first quarter), Saron (Congregational), Troedyrhiw, Glamorgan.

most prominent and impressive of the 'historical' images allowed into chapels. The main feature of many banners, apart from a scroll bearing a text or the name of the Sunday School, is a large and colourful image representing a biblical event or illustrating a text. The images were painted in oil in the middle of a rectangle of pure silk, which sometimes measured six feet wide and nine feet high (**14**). The finest examples of banners were, according to their manufacturer's advertisements, those of George Tutill of London, whose advertisement in the *Baptist Handbook* of 1909 claimed that 'You *cannot* get a better article than he supplies. The silk is woven on the premises, and the paintings are *Artistic* and *Effective*'[36] (**15**). The most popular subject for these works of art by far was the baptism of Christ, which came complete with a representation of Christ and a descending dove. Inevitably, such an image was not only a 'historical' representation but also propaganda for Baptist doctrine.

Banners were paraded in the Whitsun Marches, rather like the Roman Catholic Church process images of saints and the virgin Mary on saints' days. When not on public display the banners were hung on the wall behind the pulpit, especially during events like the *cymanfa ganu* and eisteddfod (**16**). The height at which they were hung meant that the images were obscured by the minister when he stood up to conduct the service. Their interaction with the proceedings of worship was therefore minimized. There were probably many reasons for the setting up of these banners. When the pulpit was vacant, those that bore a biblical text played much the same role as the painted scrolls. Colourful images like Christ carrying a lamb or walking on the waves would have appealed to the imagination of the children (**Plate 2**). For those

too young to read, the images would have been a means of biblical instruction. In principle, the use of images on banners was no different from the Roman Catholic practice of setting up images as the 'books of the unlearned'.

In Nonconformity, and according to the New Testament, the word 'saint' refers to every Christian, as distinct from the Roman Catholic use of the word, which denotes a dead person who has officially been canonized for having lived an exceptionally holy life. 'Pictorial' images of contemporary saints, for example ministers and church officers, were hung in the chapel vestry, the Sunday School room, and the 'sanctuary'. These were either photographs or paintings put up by congregations in memory of those who had faithfully served in the chapels. A painting of the famous Baptist preacher Christmas Evans (1766–1838) hung behind the pulpit of his chapel in Caernarfon until recently. (The portraiture of Nonconformity is discussed in Chapter 3.) Alongside them were hung images of saints of old, for example Leonardo da Vinci's (1452–1519) *Last Supper* (1495–7), reworked in Berlin wool-work embroidery, was hung on the front of the pulpit above the communion table in some chapels (see Chapter 2). (*The Light of the World* underwent the same transformation.) From the latter part of the nineteenth century these images were accompanied by a liberal array of chromolithographic prints of Old and New Testament scenes similar to those found in illustrated Bibles. Stories like Noah's ark, David and Goliath, and Christ blessing the children were among the most popular. The pictures were an important aid to teaching children in the chapels' Sunday Schools (see Chapter 4).

The latter part of the nineteenth century also saw a massive and widespread disaffiliation of the Welsh from the ranks of Nonconformity. Among the contributory factors, as C. R. Williams has argued, were the apathy of chapels towards the social conditions of industrial workers, the appearance of a 'new theology', the 'new knowledge' in the form of the work of Darwin and other scientists, and new cultural and leisure-time activities together with the accompanying indulgence in alcohol, blasphemy, and disregard for the Sabbath, or Lord's Day.[37] Some Nonconformists believed that only a divine visitation in the form of another religious revival could turn the tide of irreligion and return Nonconformity to the cause of true piety and its former prosperity. (The desire was subsequently realized in 1904, when an estimated 100,000 converts were added to the denominations.) Others believed that the solution to the problem of winning back and retaining the allegiance of the Welsh was to reform the external aspects and activities of the churches. In an article published in the *South Wales Daily News* in January 1905, the Congregational minister H. Elwyn Thomas described the ways in which art could participate in the churches' programme of adaptation to new needs. In the ideal chapel of the new century 'Stained glass windows illustrating great Scriptural and historical incidents were to be fixed. Similar scenes were to be painted on the ceiling. The walls were to be hung with pictures chiefly portraits of the great and good . . . All the corners filled with statues and evergreens.'[38]

The religious revival of 1859 inaugurated the period of ornamentation in the chapel; the revival of 1904, according to Thomas's vision, was ushering in a period in

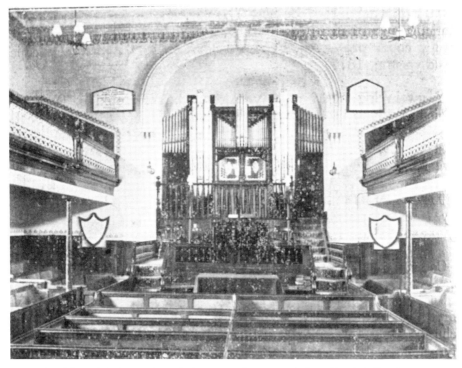

17 Memorial plaques (twentieth century, first quarter), Soar (Baptist), Pontlottyn,
Monmouthshire.

which the big town chapels would commission high art to illustrate the doctrines of
the Nonconformist churches, to commemorate and honour their great leaders and
the notable events of their history, and to provide godly and edifying decoration on a
scale unprecedented in the previous half-century. What was being envisaged was a
context of worship comparable in grandeur to that of the established churches. The
'beautiful churches' thereby created would, he believed, in a small way make tangible
something of the majesty of God and heaven and produce an environment that
would promote and express the congregations' love for God.

The proposed conscription of art also reflected the establishment of
Nonconformity. No longer persecuted and forced to hold clandestine meetings in
barns and fields, the Dissenters had been able to build permanent places of worship
which, as a result of the eighteenth- and nineteenth-century revivals, multiplied and
filled rapidly. They had become the largest and most influential religious group in
Wales, a position that looked likely to be strengthened with the dawn of the new
revival. Thus Thomas's chapel was an ideational monument to Nonconformist
prestige, adorned with works of art commensurate with its status. In this way, visual
art was called to serve the chapels as a symbol of the grandeur not only of God but
also of the Free Churches. By transforming the interior of the chapel, Thomas was
effectively planning to alter the public image of Nonconformity, of which the chapel
had become the symbol and cultural centre. Anyone entering a chapel designed in

the manner of his reforms would have been made aware of a growth in visual consciousness. The recruitment of art was also intended to promote an image of cultural erudition, of an aesthetically informed and attractive religious milieu, and of a church that was moving with the times. Those who believed that it was the old and tired forms, rather than apathy to religion, that had caused the exodus from the chapels may also have thought that the face-lift would bring the masses back to the pews by offering them a new ecclesiastical context.

Thomas's chapel was to remain an unfulfilled vision. By 1911 the membership of the chapels had begun to dwindle once more, a decline that was to worsen after the First World War not only because of its casualties but also as a result of an abandonment of faith both in the goodness of God and in the idealism of the new century. By 1918 the chapel had lost much of its hold on the social and religious life of Wales.[39] The gradual reduction in the size of the congregations inevitably meant a corresponding decline in chapel revenue. Consequently, even where there was the will there were not the economic resources for commissioning the fine arts in the service of the chapels in the ways Thomas had outlined. Architectural descriptions in the denominational yearbooks from 1905 to 1918 show that a number of chapels were fitted with stained-glass windows, usually illustrating scenes from the Gospels, which had been the practice during the second half of the nineteenth century. They were frequently installed as memorials to departed ministers, as a gift from the congregations. A few chapels appear to have countenanced statuary in memory of the dead of the two world wars. More popularly, memorials took the form of plaques supplied by companies in London, Liverpool, Birmingham, and Manchester and ornamented with either Gothic or classical motifs, according to the architectural style of the chapel, and sited on the interior walls (**17**).

The use of any visual representation in the chapels, either actual or envisaged, points to discrepancies between Nonconformist practice and the principles of Reformation doctrine as defined by Calvin. The question is whether the deviation from prescribed practice was, as Calvin believed, a consequence of spiritual decline. A more likely explanation, however, is that few people in the congregations had read or even understood Calvin's discourse on art. His ideas were, moreover, not major doctrines ratified by any church council; they were his own inferences drawn from principles of Scripture, and only recommendations to be followed.

Despite their allegiance to denominations and unions, the congregations seem to have been autonomous in the fitting and upkeep of their chapels. The extent to which images were introduced was probably determined by preference and disposable income. This would explain why some chapels had a considerable number of artefacts and others relatively few. The presence of visual artefacts shows that the chapels were not devoid of artistic elaboration, and indicates a greater degree of acceptance of art and of its use in Nonconformity than has been popularly believed.

2

Art in the Service of the Home

> It is a good thing when a Man hath a House of his own thus to convert it into a Church, by *dedicating* it to the Service and Honour of God, that it may be a *Bethel*, a House of God . . . Let *Holiness to the Lord* be written upon the House, and all the Furniture of it, according to the Word which God hath spoken. Zech. 14.20, 21. That every Pot in Jerusalem and Judith *shall be Holiness to the Lord of Hosts* . . . Look upon your Houses as Temples for God, Places for Worship, and all your Possessions as dedicated things, to be us'd for God's Honour, and not to be alienated or profan'd.
>
> Matthew Henry, *A Church in the House: A Sermon concerning Family-Religion*[1]

Religion for Nonconformists was not confined to Sundays or to the chapel. The six days given to man to labour were also days in which he was to seek God, worship Him, and grow in a knowledge of the Bible. The setting for these pieties was the home, in which the family was the congregation and the head of the household its minister. The necessity of a religious life in the home was frequently stressed during the eighteenth century. In a sermon of 1704, the Welsh minister and Bible commentator Matthew Henry (1622–1714) impressed upon his congregation the motives for having a devotional life at the hearth and its benefits. His discourse became the pattern of family devotions for succeeding generations.

From principles in the Old Testament and the practices of believers in apostolic times, Henry inferred: 'That the Families of Christians should be little Churches: Or thus, That where-ever we have a House, God should have a Church in it.'[2] Since the three things necessary for the well-being of a church were doctrine, worship, and discipline, these were also to be present in the family. A knowledge and understanding of Christian teaching was to be cultivated by the reading of Scripture to the family; and children were to be catechized, to instruct them in the right way. Prayer was to be made by the family to beseech God's blessing upon the home, in the confession of their sins, and in supplication for their own and others' daily needs. They were also to worship by singing hymns. Discipline was the responsibility of the parents, to be administered by way of approval of what was good and admonition of what was evil. Not only was the family to be thus consecrated 'to the Service and Honour of God', but so was its home and everything in it.[3] The idea of introducing holiness into the common things of life derived from Zechariah, chapter 14, where the prophet foretold a time when the Israelites would no longer observe a distinction between the sacred and profane, when common men, and even the accoutrements of

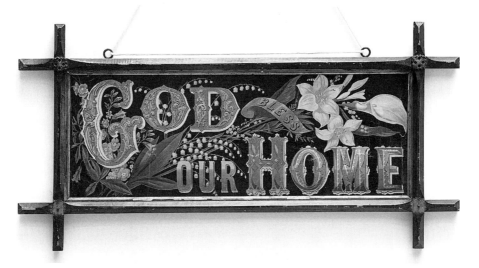

18 Painted ornamental text: 'God Bless our Home' (nineteenth century, last quarter), colour lithograph.

the horses, would be considered as set apart for God: in the latter case, the horse's bridle would bear the inscription 'Holiness unto the Lord' (verse 20), a phrase originally reserved for the high priests of Israel. Commenting on these verses, Henry wrote: 'Travellers shall have it upon their bridles with which they guide their horses . . . to guide themselves in all their motions by this rule . . . The furniture of their houses too shall be consecrated to God, to be employed in his service.'[4] He considered the teaching of these verses as applicable to God's people in his own day, and recommended that his congregation write 'Holiness to the Lord' upon their houses and all the furniture in them.[5]

Nonconformists in the nineteenth century appear to have understood the exhortation not as a figure of speech but literally, and inscribed the Word of God on the furnishings of their homes, in particular decorative artefacts such as printed and painted texts, ornamental plates, and samplers. These, together with embroidered and printed pictures of biblical characters and events, and prints and figurines of famous preachers, were used not only to decorate the home but also to instruct its occupants in the knowledge of God, true religion, and godly living. Thus religion in the home was mediated and fostered not only through the literary and oral means prescribed in Henry's sermon, but also by means of visual artefacts.

Text-bearing Artefacts

A benediction on the family and a prayer for the home was often invoked by means of a printed or painted text bearing the words 'God Bless our Home' (**18**). Those made during the late eighteenth and early nineteenth centuries usually have the words

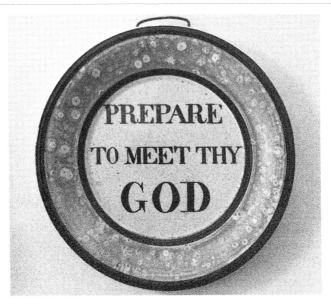

**19 Ornamental plate with text: 'Prepare to Meet thy God'
(nineteenth century, second half), probably Staffordshire ware.**

painted or stencilled in austere black letters on a plain background. Late-nineteenth-century examples reflect Victorian tastes in typography and decoration, and were either printed or painted by hand in ornate and brightly coloured letters of various shapes and sizes, interwoven with flowers. Biblical texts, too, were presented in this way, the texts chosen either extolling an attribute of God or declaring His precepts and commandments, like those illuminating the chapel walls. The texts chosen to ornament the home also encouraged families to examine themselves and to consider their destiny. 'Prepare to Meet thy God' is seen on ornamental plates, crudely painted in a bold black roman face across a white centre (**19**). These would have hung on the walls as *memento mori* to urge families to order their ways in the light of the coming judgement, and thereby acted as a deterrent to immorality and irreligion. The plate would also have served as a means to evangelize the unconverted neighbour who entered the home. Other examples, such as ornamental plaques, have the words embellished with painted flowers, which convey a sense of sweetness and delicacy that is often at odds with the solemn sentiment of the text (**Plate 8**). Plaques such as this, as Griselda Lewis has established, were made in Staffordshire after John Wesley's (1703–91) tour of the potteries in 1781, at a time when religious fervour was sweeping through the country.[6] During the period 1829 to 1866, Staffordshire potters and their families migrated to Llanelli to work in the local potteries. Around 1840 to 1850 the Llanelli potteries manufactured a number of pictorial and text-bearing plates, chiefly for children, not unlike the types produced in Staffordshire and made, presumably, by the former Staffordshire potters.[7]

Personal piety was also fostered by perhaps the most common type of text-bearing artefact in the Nonconformist home, the sampler. These were made by the

female children of the household at school or in the home, and were traditionally conceived as an exercise in needlework. They were usually embroidered on canvas in a variety of stitches and colours. Many examples were decorated with numerals or letters of the alphabet. Virtually all the embroidered samplers had the inscription of either a pious verse, a moralizing poem, or a text from the Bible. Among the biblical passages most frequently incorporated were the Ten Commandments or the Lord's Prayer. The sampler was thus a means of teaching needlework, literacy, and religion to children, enabling them in the common tasks of life to grow in their desire for and their knowledge of God; for example the inscription from a sampler worked by Mary Lewis in 1824 (**Plate 3**):

> Jesus permit thy gracious name to stand
> As the first effort of an infants hand
> And while her fingers on the Canvas move
> Enlarge her tender heart to seek thy love.

Inscriptions were usually surrounded by embroidered motifs of a house, bird, baskets of flowers, and animals. Christian imagery was also employed, the most common being the cross, sometimes accompanied by Adam and Eve standing by the tree of knowledge or denoted by the letters A and E.[8]

In the sampler the verse of Scripture is one of several components; in the embroidered biblical texts it is the dominant feature. In the latter the Word of God is often adorned with elaborately wrought capitals and entwined in the tendrils of a vine, the biblical symbol for Christ. Single verses in a Gothic face were generally preferred and, like the painted texts on chapel walls, were in some instances incorporated into representations of unfurled scrolls. In other examples the outlined images of a cross or open Bible appear as visual adjuncts to the text or play a more dominant role in the design, acting as vehicles for conveying part of the verse. Designs for the more elaborate biblical texts would have been bought from needlework suppliers. Texts proclaiming the merits of the Bible and verses from popular hymns were also celebrated in these ways (**20**). Along with samplers, embroidered Bible texts were framed and hung in prominent positions around the home, as, for example, in Mrs Dai Bread Two's vision in *Under Milk Wood*:

> I see a featherbed. With three pillows on it. And a text above the bed. I can't read what it says, there's great clouds blowing. Now they have blown away. God is Love, the text says.[9]

The religious ethos of the text-bearing artefacts was sometimes emphasized by an Oxford frame, 'a picture-frame the sides of which cross each other and project at the corner' (*OED*), forming the symbol of the cross at each intersection (**18**). The admission to a place of worship of such a non-sacramental symbol was clearly a deviation from Calvinistic doctrine.

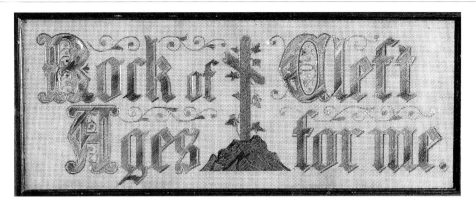

20 Embroidered text: 'Rock of Ages Cleft for Me' (nineteenth century, second half).

The practice of displaying Scripture on the walls of the home had a biblical precedent. In the Old Testament the Israelites were commanded to write certain parts of the Law on the posts and gates of their homes in order that God's Word be kept not only in their hearts but constantly before their eyes, and for a remembrance of their duties and of God's goodness towards them (Deuteronomy 6:6–12). Commenting on this precedent, Henry wrote:

> Means are here prescribed for the maintaining and keeping up of religion in our hearts and houses, that it might not wither and go to decay . . .God appointed [the Israelites], at least for the present, to write some select sentences of the law, that were most weighty and comprehensive, upon their walls . . . It was prudently and piously provided by the first reformers of the English church, that then when Bibles were scarce, some select portions of Scripture should be written on the walls and pillars of the churches, which the people might make familiar to them.[10]

The texts 'written' upon the walls of the Nonconformist home served the same end of sustaining personal piety and family religion. Arguably, the example of the Israelites provided the earliest precedent for painting and stencilling texts on the walls not only of sixteenth- and seventeenth-century English churches, as Henry suggests, but also of Nonconformist chapels in the second half of the nineteenth century. The Scriptures written on the walls of posts and gates of Old Testament homes were also a means by which the Israelites taught God's commandments, statutes, and judgements 'diligently unto [their] children', as God had instructed (Deuteronomy 6:7). Similarly, biblical texts and pious verses on the walls of Nonconformist homes would have had a didactic purpose, being a means by which children learned and were reminded of the tenets of the faith.

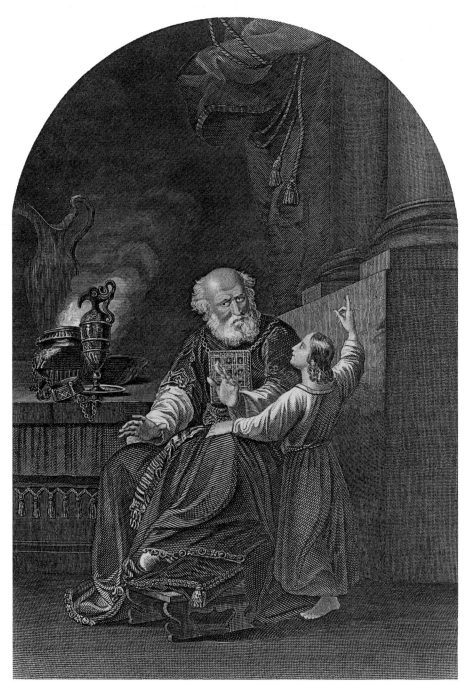

21 Bible illustration: 'Samuel and Eli' (1 Samuel 3:8), engraving by S. Allen after a painting by J. S. Copley, *Bibl yr Addoliad Teuluaidd* (Swansea: J. Nicholas, [n.d.]).

Images

Henry exhorted his congregation to look on their houses as 'Places for Worship', in a reference to the sanctuaries of Jehovah in the Old Testament.[11] The Tabernacle was such a place, a portable habitation of God used by the Jews before they settled in Palestine. Among its interior fittings were ten colourful curtains embroidered with images of cherubim (Exodus 26:1); these images were to remind the Israelites of heavenly realities. Embroidered images that adorned the sanctuary of the home served the same purpose. This form of embroidery had its origins at the beginning of the nineteenth century and was known as Berlin wool-work. Barbara Morris describes it as 'a type of canvas embroidery, worked in worsted wools, mainly in tent- or cross-stitch on a square meshed canvas, the designs being copied stitch by stitch from patterns printed on squared paper, each square of the printed design representing one square of the canvas'.[12] Berlin wool-work received its name from having its designs and materials imported into England from Berlin by leading publishers of engravings. Many of the subjects for the designs were derived from famous works of art, and reflected an interest in romantic, pastoral, and historical themes. Scenes from the Bible were very popular and were based on engravings of paintings by the Old Masters. The embroidered pictures that hung in Welsh homes depicted incidents from both Old and New Testaments. Scenes of Samuel and Eli (**Plate 5**), the flight into Egypt, and the Last Supper were common, popularized by their appearance in the Welsh illustrated Bibles (**21**) (see Chapter 4).[13]

The Old Testament stories provided a rich supply of lessons and morals for the embroiderer and her family to apply to their lives. Hanging on the walls of the home, the embroidered pictures may well have provided a focus of conversation and an opportunity for parents to catechize their children regarding the identity of the characters and the meaning of the events represented. They may also have provided an illustration to a fireside or bedtime Bible story or to the reading of Scripture in family devotions. During the nineteenth century pictorial embroideries were also applied to upholstery and domestic furnishings, like chair-backs, cushions, and standing fire-screens. A chair in the Welsh Folk Museum, Cardiff shows an embroidery of the psalmist David playing his harp. This particular biblical theme was prevalent in both illustrated Bibles and Sunday School literature, its popularity deriving in part from its reference to the national musical instrument. Berlin wool-work was, according to Morris, predominantly a pursuit of the leisured classes. Therefore, the embroidered pictures would probably not have been common in the homes of the working class, who accounted for the vast majority of Noncon-formists during the nineteenth and early twentieth centuries.

A personal appraisal of religious pictures in the working-class homes of south Wales was made by D. Cunllo Davies in 1895. In his capacity as a Nonconformist minister, Cunllo Davies would have made frequent pastoral calls on the members of his congregation, and his observations are probably derived from these visits:

The Welsh working man has but a darkened eye to see and enjoy the beautiful in art. Indeed, in the mining towns of South Wales, he seems to have no eye whatever. He rarely rises higher in the decorating of his home than the highly-coloured caricatures of Biblical characters, sold by hawkers at his door. The grocer's almanac, framed in gilt, appears to be the highest step to which he has ever advanced in the appreciation of art. Here and there one finds a picture of Gladstone, John Bright, or Spurgeon. These hang on the wall because the Welshman has a very decided view in matters political, a one-sided hero worship, and a deep place for religion and its leaders.[14]

It was his belief that the small number and limited range of domestic pictures reflected an absence of 'true aesthetic feeling' in the Welsh people.[15] From his descriptions, it is evident that religious pictures in the home fell into two categories: the first can be subdivided into the two classes of representation defined by Calvin, the pictorial, consisting of the 'highly-coloured caricatures of Biblical characters', and the historical, including such incidents from the Bible as the crucifixion, Christ in the tomb, and a scene from the parable of the prodigal son; the second comprised images of more contemporary religious figures, namely the great preachers and leaders of Nonconformity.[16]

In the nineteenth century, characters and scenes from the Bible were often represented in the form of glass paintings, made by transferring a printed reproduction, like the chromolithographic illustrations in family Bibles (**Plate 6**), on to the reverse of a small pane of glass. The technique probably involved coating the reproduction with varnish and adhering it to the glass; the glass was then soaked in water so that the paper on the back of the reproduction, which had not been coated in varnish, could be rubbed off, leaving the black outline of the illustration on the surface of the glass. The outline was then painted in by hand to resemble the illustration. The completed picture was partially translucent, but since there was only the dark backing-board of the picture-frame behind, its colours looked subfusc (**Plate 7**). The glass paintings were probably made by pedlars and sold at the doors of both Protestant and Roman Catholic homes (Cunllo Davies's article mentions hawkers).

Like Calvin, Cunllo Davies believed that pictorial representations were capable of nurturing a distorted view of God and religion, especially in those who had been reared in homes with no religion at the hearth and whose minds were therefore uninformed by the teaching of Scripture. He also criticized pictures of biblical scenes that deviated from history and the record of Scripture. Concern for authentic representations of biblical history characterized Nonconformists who took a positive interest in the visual arts (see Chapter 4). Cunllo Davies remarked of a picture of the crucifixion, which showed the hideous features of resurrected saints clambering from their graves: 'What historian ever taught that there was a cemetery on Golgotha? and what Bible ever said that the resurrection from the dead was such a scene of horror?' Sordid religious pictures such as this were further denounced on the grounds that they only bred melancholy 'in those who gazed upon them', and

22 'John Elias' (nineteenth century), engraving by S. Bellin after
a painting by H. Jones, published by T. Thomas (Chester).

with iconoclastic fervour, he suggested that they be destroyed. The reason for having pictures in the home was not to induce depression but, he believed, rather 'to dispel care and trouble', 'to purify feelings', and to elevate ambition.[17]

Among the pictures that fulfilled this criteria were the prints representing great preachers and leaders of Nonconformity. Cunllo Davies recollected how, in his childhood, images of the Welsh Calvinistic Methodist ministers John Elias (1774–1841) and Owen Thomas (1812–91) were hung on the walls of homes (**22**). Portraits of Welsh preachers were reproduced by printing and publishing companies in Wales and England, and many were also used as frontispieces to their books.[18] In addition, their likenesses were captured in Staffordshire ware figurines, together with the Nonconformist worthies John Wesley, C. H. Spurgeon, and the American evangelists Dwight Moody (1837–99) and Ira D. Sankey (1840–1908) (see Chapter 3). These portraits not only served to honour and capture the likenesses of great men, but were also emblems of lives worth emulating. In this way, the images were instrumental in moulding the characters of young men, determining the path their lives would take, and creating in them a longing after the same goals: 'Many of our

foremost pulpit orators, in the absence of any other stimulus, have been captivated
by the idea of preaching, by these silent relics of the kitchen home. They have been
the potent elevators of youthful ambition.'[19]

Davies recognized art's ability to 'teach ideals through the medium of pictures',
whether for better, as in the case of portraits of preachers, or for worse, as in the
case of caricatures of biblical characters.[20] In the early twentieth century this
potential was used beneficially in *Salem* (1908), painted by S. Curnow Vosper
(1866–1942). The picture, which shows Salem Chapel, Cefn Cymerau, Cwm Nantol,
Merioneth, is an emblem of traditional Welsh life, the values of which had been
eroded in the south by the onslaught of industry, the development of urban
communities, and the immigration of foreign workers to exploit its resources. *Salem*
appealed to a nostalgia for the old ways of life, and found a place on the walls of
many houses during the twentieth century. Several legends grew up around the
painting, one of the most popular being that the old lady, on entering the chapel,
took pride in her shawl and committed the sin of vanity, which 'accounts for the
features of the devil which can be picked out among the folds over the arm holding
the Bible'.[21] *Salem* would have warned Nonconformists to beware the hypocrisy of an
outward show of religion and a heart that was far from God.

As the simplicity of the interiors of eighteenth-century barn-chapels had been
reflected in that of the Nonconformist home, so the pictorial elaborations and
ornaments of nineteenth-century chapels were echoed in domestic decor: the same
types of artefacts – texts, and historical and pictorial images, including portraits of
leaders and preachers – were common to both. The similarities derive, to a great
extent, from the chapel and the home being considered, alike, as 'sanctuaries' of
God. Furthermore, Nonconformists would not have tolerated any qualitative
disparity between God's house and their own, a principle derived from the Old
Testament story of King David. Having built himself a palace, he determined to
have no rest until God, as symbolized by the Ark of the Covenant, had a dwelling
place at least as resplendent as his own: 'See now, I dwell in an house of cedar, but
the ark of God dwelleth in curtains' (2 Samuel 7:2).

While Matthew Henry considered godly living to be the most suitable and
necessary means by which Christians ought to 'adorn and beautifie' the church in the
house, he did not prohibit the use of art also for this purpose, as Calvin had
prohibited historical and pictorial representations for the church building proper.[22] A
house, after all, was a 'church' only by an honorific extension of that term, and thus
there was no reason why ecclesiastical principles should be applied to it. The
Reformers, too, neither censured nor restricted the service art could render to the
home. Indeed, it is conceivable that, since Calvin considered 'historical'
representations to be inexpedient in the church but useful for teaching, he might
have countenanced the Christian home as a legitimate context for such a use. Martin
Luther (1483–1546) believed that the pictorialization of the Bible in the home was
useful 'for the sake of remembrance and better understanding' of the Scriptures, and
wrote of his longing 'to persuade the rich and mighty that they would permit the

whole Bible to be painted on houses, on the inside and outside, so that all can see it'.[23]

In applying texts to crockery and needlework, and scenes from the Bible to pictures and upholstery, the furnishings of the Nonconformist home were 'us'd for God's Honour' in a practical way as media for communicating His Word. In this way, artefacts could serve family religion as an aid to teaching and admonition; and in the daily routine of domestic life as a reminder of the God whom the family served, of the ways in which they were called to walk, and of the heavenly home for which they were destined.

3

Art in the Service of Commemoration

The Lord spake unto Joshua, saying, Take you twelve men out of the people, out of every tribe a man, and command ye them, saying, Take you hence out of the midst of Jordan, out of the place where the priests' feet stood firm, twelve stones . . . That this may be a sign among you, that when your children ask their fathers in time to come, saying, What mean ye by these stones? Then ye shall answer them, That the waters of Jordan were cut off before the ark of the covenant of the Lord; when it passed over Jordan, the waters of Jordan were cut off: and these stones shall be for a memorial unto the children of Israel for ever.

<div align="right">Joshua 4:1–7</div>

Ye shall make you no idols nor graven image, neither rear you up a standing image, neither shall ye set up any image of stone in your land, to bow down to it: for I am the Lord your God.

<div align="right">Leviticus 26:1</div>

In the Judaeo-Christian tradition remembrance is regarded as an expression of both religious duty and devotion, evident in the Bible's frequent exhortations to forget neither the Lord God nor 'all his benefits' (Judges 3:7; Psalm 103:2). The memory of God's character and acts were preserved and celebrated in the historical books of the Bible, particularly the poetic works such as the Psalms (Psalms 38 and 70). Literary artefacts were not the only vehicle of commemoration. In the Old Testament, God had instructed that memorials be raised as tangible and enduring testimonies to Israel's history; to perpetuate the memory of significant events in which He had been directly involved (Joshua 4:7; 1 Samuel 7:12); and as the symbolic witness to a covenant between Himself and His people (Genesis 28:18) or between two Israelites (Genesis 31:45). The memorials were made by setting up a large stone or group of stones in the place where the event had happened. No attempt was made to refine or elaborate their rude forms, for to have done so would have been to transgress the commandment against idolatry which forbade the setting up of an 'image of stone' in the land (Leviticus 26:1).

Like the Israelites, Nonconformists carried out the Bible's injunctions to remember and memorialize using a variety of means, both literary and visual. Numerous histories of individual chapels were published during the early part of the twentieth century to mark the centenary or a major refurbishing of the buildings, and

23 Architectural lettering (nineteenth century, second half), Tabernacle (Congregational),
Narberth, Pembrokeshire, photograph by John Thomas.

to commemorate God's faithfulness in providing ministers, church officers, converts, and the resources to establish and maintain the fabric of the chapel. The chapel histories were, in the spirit of the Psalms, also a means of encouraging future generations of believers to trust God for the same. Biblical history was also commemorated. Like the patriarch Jacob, the congregations of Wales erected monuments to their vision and called them 'Bethel'. Unlike Jacob's memorial, theirs was not a monolith but chapels, many of which bore the names 'Bethel', and also 'Ebenezer', 'Salem', 'Elim', and 'Nazareth', among others. Some of the names were originally those of Old Testament memorial stones, while others were the names of important places in the annals of Judaism and the life of Christ. These names appeared, usually in a grotesque letterform, either carved on a plaque inserted into the façade walls or in large painted letters spread across the width of the façade, above and between the upper-storey windows (23). Like the painted texts on the interior walls of chapels, façade lettering was a vernacular style. During the Regency and early-Victorian periods lettering was used on all types and sizes of buildings

including public houses, hotels, and manufactories.[1] It could be employed to striking visual effect, in many instances echoing elements of the architectural pattern, adopting a curved, circular, or ovoid formation. By virtue of these names many of the chapels became latter-day monuments to biblical history.

Nonconformists desired to honour and to keep alive the memory of their own history too, and commissioned or adopted a variety of the fine and graphic arts to this end. Just as their view of art as an aid or accessory to worship was influenced by the teachings of the Reformers, so also was their attitude to the use of art in the service of commemoration. The Reformation view of memorials was inexorably tied to the debate about the permissibility or otherwise of religious images and the prohibition of idolatry. Luther supported his position in favour of images by recourse to the commandment in Leviticus, chapter 26, forbidding the setting up of a 'standing image' or an 'image of stone', which, he argued, was given to prevent idolatry, but did not imply that images *per se* were to be subject to censure: 'Where however images or statues are made without idolatry, then such making of them is not forbidden, for the central saying, "you shall have no other gods", remains intact.'[2] Thus, he wrote, it was possible to 'look at a crucifix or a Madonna, yes, even an idol's image, in full accord with the strictest Mosaic law, as long as I do not worship them, but only have them as memorials'.[3] Luther considered that the making of images and statues was separable from the issue of idolatry, and thus they were a permissible form of memorial. Calvin was of the contrary opinion on both accounts: he ridiculed papist 'pictures or statues to which they append the name saints' as 'exhibitions of the most shameless luxury and obscenity',[4] and would not countenance the practice of honouring the dead by these means, which practice, he was convinced, was at the root of idolatry:

> In regard to the origin of idols, the statement contained in the Book of Wisdom has been received with almost universal consent, viz., that they originated with those who bestowed honour on the dead, from a superstitious regard to their memory. I admit that this perverse practice is of very high antiquity, and deny not that it was a kind of torch by which the infatuated proneness of mankind to idolatry was kindled into a greater blaze.[5]

Portraiture

Memorial pictures and statues dedicated to 'saints' living and dead were Nonconformity's most conspicuous expression of commemoration. The motivation to honour the worthies of the faith derived from biblical principles. The Apostle Paul exhorted congregations to count 'worthy of double honour' those ministers who ruled well, 'especially they who labour in the word and doctrine' (1 Timothy 5:17). Calvin interpreted 'honour' as referring 'not only to the reverence which is due to them, but to the recompense to which their services are entitled'.[6] Similarly,

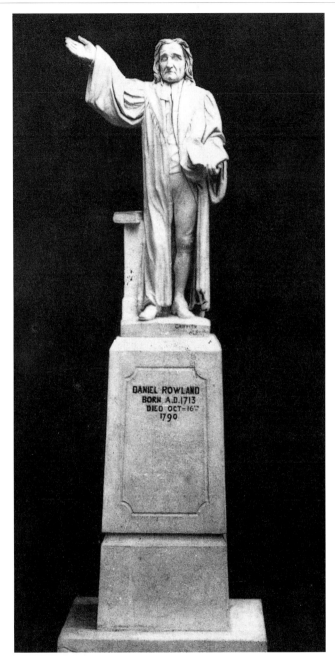

24 'Daniel Rowland' (1883), carte-de-visite photograph by
Horace G. Pike, Chester, of the statue by Edward Griffith.

Matthew Henry regarded 'honour' as bespeaking care for ministers, ensuring that
they did not suffer poverty.[7] Neither Scripture nor Calvin, however, gave any warrant
for honouring ministers by means of memorial or commemorative images.

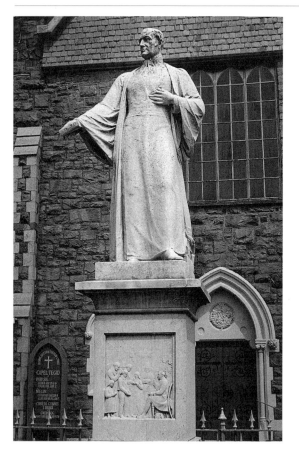 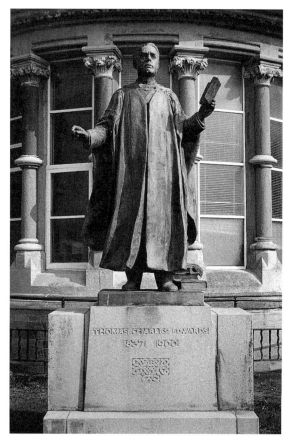

25 (left) *Thomas Charles* (1875), by William Davies, marble, Capel Tegid (Calvinistic Methodist), Bala.

26 (right) *Thomas Charles Edwards* (1922), by William Goscombe John, bronze, Old College, University of Wales, Aberystwyth.

The images Nonconformists commissioned to honour the church leaders comprise mainly prints, photographs, and paintings, together with ceramic figurines, sculptured busts, and a relatively small number of statues to the late and great worthies of Nonconformity. The paucity of memorial statues was a consequence not only of the considerable financial burden that commissioning these works involved (almost as much as the cost of the construction of a small chapel) but also of the danger, to which Calvin had drawn attention, that images consecrated to the dead might incite idolatry.[8] Furthermore, in employing both a sculptor and the use of representation, Nonconformity departed from the Old Testament tradition of commemoration, and opened itself up to the perils of idolatry consequent upon the setting up of 'an image of stone' in the land (Leviticus 26:1).

Theological unease was reflected, in the case of two of Nonconformity's greatest leaders Daniel Rowland (1713–90) and Thomas Charles (1755–1814), in the considerable delay in erecting memorials after their deaths. Ninety-three years

intervened the death of Rowland and the erection of a marble statue of him by
Edward Griffith of Chester in the chapel grounds at Llangeitho in 1883 (**24**).
Thomas Charles died in 1814, but it was not until 1875 that a statue was set up
outside the Welsh Calvinistic Methodist chapel at Bala (**25**). Thomas Charles was one
of the chief Methodist leaders in the nineteenth century, founder of the Welsh
Sunday Schools, and one of the founders of the British and Foreign Bible Society.
Any hesitancy in honouring him was not, therefore, due to doubt as to his merit.
D. E. Jenkins suggests that the reason for this delay was concern that an image of the
preacher might encourage excessive admiration: 'The Welsh people never had any
enthusiasm for statues, except in their state of animation – when even they can
become dangerously near being idolaters. A long time elapsed before anyone seemed
to have sufficient courage to suggest a monument even for Mr Charles's grave.'[9]

While the Charles statue was completed eight years before that of Rowland, the
intention to erect a monument to Rowland preceded it by over a decade. Even in
1864 it was considered that a tribute to Rowland was long overdue. A resolution was
passed at various meetings of the Calvinistic Methodist Church to convene a
working party consisting in part of the most influential men of Wales from every
denomination, and to ask for subscriptions towards the cost of the statue from every
class and denomination, since all had benefited from his ministry.[10] The attempt
failed, but the intent was revived in the same year Charles's statue was unveiled;
indeed the setting up of the memorial to Charles would seem to have been one of
the contributory motives for a statue to Rowland, completed some eight years later.
The absence of a statue to Rowland was not only long overdue but also unbefitting.
As one writer in *Trysorfa y Plant* ['The Children's Treasury'] for 1883 wrote:
'Monuments having been erected to Harris [Howel Harris, 1714–73] and Charles, it
appeared incongruous that the chief doubtless of these three Rowland, and the most
powerful and successful preacher that Wales has ever seen, was without a
memorial.'[11] Nevertheless, some Calvinistic Methodists were not persuaded and
resisted the idea of the memorial. This was one reason for the failure of the initial
attempt, and for the considerable problems that the organizers faced in raising
sufficient funds to cover the cost of its execution on the second attempt. The writer
continued: 'Not everyone sees the appropriateness of erecting a statue to Daniel
Rowland, and some have quoted a line of Williams's [William Williams, Pantycelyn,
1717–91] elegy to him as against it: "It is not necessary to sing anything about
him,/He needs no marble on his grave," etc.'[12] For such, the legacy of Rowland's life
and work was considered a sufficient memorial. However, Rowland himself said,
according to David Jones, Dolau Bach, an old church elder, that *he* did not believe
himself to be unworthy 'of the best marble on his grave', thus giving what was
thought to have been his tacit sanction of the statue.[13]

It is not clear what motivated Welsh Nonconformists to transcend their qualms
and commission memorial statuary. Since Harris, Rowland, and Charles were
regarded as eminent national as well as religious figures, the absence of some form
of monument may have been considered both disrespectful and unpatriotic.

Furthermore, English Methodism had already created a precedent for commemorating ministers in this way by establishing a statue to one of its most noted preachers, John Wesley, around 1830.[14] Like the resplendent chapels of the second half of the nineteenth century, the statues served as monuments not only to great preachers but also to Nonconformist establishment and prestige – further tangible evidence that the Free Churches were here to stay, a force to be reckoned with. National competitiveness and denominational pride apart, the overriding purpose for setting up statues to great preachers in Wales was undoubtedly, as in the case of the memorials to Rowland and Charles, as 'a means of renewing and maintaining the honour of [their] name in the hearts of succeeding generations'.[15]

The statue to Thomas Charles was sculpted by the Welsh artist William Davies (1826–1901), whose work was selected from submissions by several designers. Davies, who was based in London, was both a sculptor and a Nonconformist (see Chapter 5). The statue depicts Charles holding out a Bible in an attitude which, Jenkins remarked, was intended to express the sentiment at the heart of Charles's ministry: 'I heartily desire that every living man shall have a Bible.'[16] The pose can also be read as a literal interpretation of the Apostle Paul's exhortation to the Philippians to hold forth the Word of life (Philippians 2:16). In traditional Christian iconography, a person holding a Bible usually denoted one of the four Evangelists; in the context of Nonconformist memorials and portraiture it designated an evangelist in the broader sense of the word, that is, anyone who was a preacher. Books, of which Charles was author, are stacked at his feet. They signify not only that he was a man of learning but also a general change in the status of Welsh ministers during the latter part of the nineteenth century as a result of a more academic education received by candidates for the ministry at the Welsh denominational colleges. No longer were they men of 'the book' only, but men of many books, and of letters too.[17] The device was also employed by one of Wales's most notable sculptors William Goscombe John (1860–1953) in his bronze statue of Thomas Charles Edwards (1837–1900), outside the Old College of the University of Wales, Aberystwyth (26). Edwards was the principal of the University College of Wales, Aberystwyth from 1872 to 1891, and later the principal of Bala Theological College until his death.

Lewis Edwards (1809–87), Thomas Charles Edwards's predecessor at Bala, was also commemorated in a bronze statue by Goscombe John, unveiled in front of the Theological College at Bala in 1910. In the opinion of one minister writing in *Wales* a year later: 'Sir Goscombe John's bronze statue will preserve to posterity the features and form of a man whose memory ought to be the greatest inspiration to the youth of Wales for all time.'[18] The sentiment recalls Cunllo Davies's view that the portraits of great preachers that hung in the home were 'potent elevators of youthful ambition' and a stimulus to those who looked on them to seek after the same goals. Thus statuary, also, was a means of promoting the ministry, nurturing a desire to preach, and ensuring the continuity of the ministerial line.

Ministers were also memorialized in bronze busts, and a number can be found in

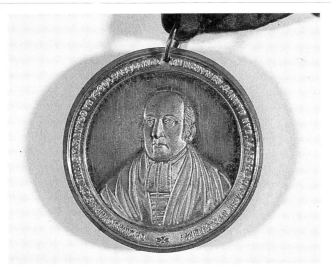

27 Medal: 'Canmlwyddiant yr Ysgol Sabbothol yn Nghymru' [*sic*]
['Centenary of the Welsh Sunday Schools'] (1885), bronze.

the Nonconformist colleges of theology, while a few have been fixed upon pedestals
in chapel grounds. A bust of Lewis Edwards faces the road outside Penllwyn
Calvinistic Methodist chapel, Capel Bangor, Cardiganshire (**Plate 11**). A bust of
Thomas Charles appeared in 1885 as a relief representation on the medal
commemorating the centenary of the Welsh Sunday Schools (**27**). The use of medals
as a means of commemoration was prevalent in both Nonconformist and secular
bodies during the Victorian era. They were founded on the occasion or anniversary
of a notable event to serve as a lasting memento. The Thomas Charles medal, made
in both tin and bronze, was preceded in 1831 by a medal made for the Welsh Sunday
Schools' jubilee. In Dolgellau, whence Mary Jones had walked to Bala to ask for a
Welsh Bible, the medals were presented to the Sunday School members.

Nonconformity's lack of enthusiasm for statuary was interpreted by some as
proof of its disinterest in art generally. Commenting on the need for a suitable
memorial to Michael Roberts (1780–1849), the famous Calvinistic Methodist
preacher of Pwllheli, one writer remarked: 'Calvinistic Methodism can not justify its
existence to lovers of art until it has erected a statue to this most eloquent of
preachers.'[19] While the fear of idolatry and prohibitive cost rather than a hatred of
art determined their lack of enthusiasm for statuary, Nonconformists, on the whole,
displayed little reticence when it came to painted and photographic portraits.
However, as Thomas Jones remarked, there were some Calvinistic Methodists who
had considerable theological qualms regarding portrait photography in particular:

Calvin wrote in his Institutes that he was not so superstitious as to object to all
'visible representations' but he would limit the range of subjects to be painted or
sculptured. With later Calvinists as with Quakers this took the form of objecting to
being photographed as savouring of pride and worldliness and though my

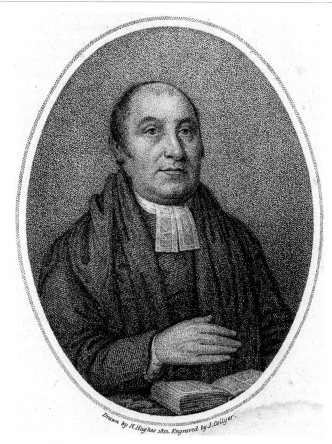

28 'Thomas Charles' (*c.*1819), engraving by J. Collyer after a
drawing by Hugh Hughes (1812), *Geiriadur Ysgrythyrawl* (1819).

grandfather was photographed under protest he used to quote to me 'thou shalt not
make unto thyself a graven image' as decisive.[20]

Most Nonconformists would not have considered that the prohibitions of the
second commandment had implications for portraiture, in any medium. The scope
of this commandment was, as Thomas Charles taught in his catechism on the
decalogue, specific. In his second answer to the question 'Which are the sins
forbidden by this commandment?' he wrote, 'To make an image or a likeness of God
or the likeness of any thing else to worship instead of God.'[21] Like Luther, Charles
concluded that it is idolatry, not image-making, which is censured thereby. Indeed,
God positively commanded the making of both pictorial and sculptural
representations to adorn the Tabernacle and the Temple of Solomon (Exodus 25:18;
26:1; 2 Chronicles 3:10–13). While the genre of portraiture did not exist in Old
Testament times, there would have been no doctrinal justification for suppressing it
even if it had. Christ did not declare portraiture to be unlawful on the occasion of
seeing the image of Caesar on the tribute money but, instead, used it as an object-

29 'Thomas Charles' (nineteenth century, second half),
engraving by E. Pick from a drawing by Hugh Hughes (1812),
Enwogion y Ffydd [n.d.].

lesson to illustrate God's claim on men's lives (Matthew 22:19–22). The Reformers, too, had legitimated painted portraits as both a permissible means of representation and a memorial. Luther was painted many times by Lucas Cranach (1472–1553), and Desiderius Erasmus (1467–1536) was portrayed writing and surrounded by books in an engraving of 1526 by Albrecht Dürer (1471–1528).

The tradition of portraits continued in the form of the frontispiece engravings of books written by Nonconformist ministers. A similar portrait to that on the centenary medal appears in Charles's *Geiriadur Ysgrythyrawl* ['Scriptural Dictionary'] (**28**). It shows him in his Geneva gown holding a reading-glass over an open Bible placed on a cushion. The open Bible symbolized the authority of Scripture, and the cushion was a symbol of majesty, after its association with the regal cushion on which the crown is presented to a king or queen at a coronation. In the first edition of the dictionary published in 1819, Charles's portrait was engraved by J. Collyer from a drawing made in 1812 by Hugh Hughes, son-in-law and biographer of Thomas's brother, David Charles. The reason for Hughes's portrait being dropped from the book's later editions may well have been his unwillingness to toe the party line in 1829. T. Mardy Rees explained that, 'being a radical in religion and politics, he

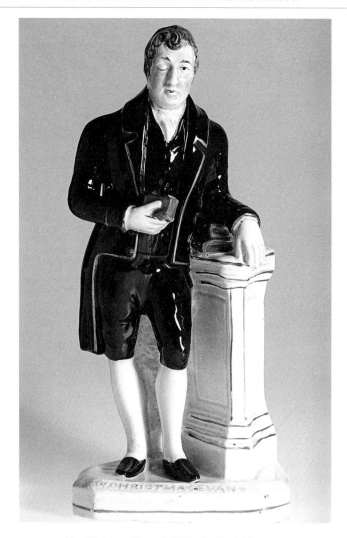

30 *Christmas Evans* (*c.*1840), Staffordshire ware.

signed a petition in favour of passing an Emancipation Bill of the Catholics (1829), and was expelled from the Welsh Methodist communion in consequence'.[22]

Engraved images of eminent Welsh preachers were also hung in Nonconformist homes and used to illustrate biographical anthologies. An example of these anthologies is *Enwogion y Ffydd* ['Famous Men of the Faith'], a series of photo-engravings published in four volumes during the second half of the nineteenth century. A modified version of Hughes's drawing of Thomas Charles is engraved by E. Pick in this volume. The oval format of the Collyer version has been abandoned to reveal the cushion and table-top on which the Bible rested (**29**). The practice of extending an image and translating it into another medium was taken one step further with Pick's engraving of Christmas Evans. The engraving, which in turn was

a variation on another image, became the source for the design of a Staffordshire pottery figure made around 1840 (**30**). During the mid-nineteenth century the Staffordshire potteries manufactured a series of figures representing famous personalities of British political and religious life. According to Thomas Balston, at least a dozen of the religious figures were Nonconformist preachers. Apart from Christmas Evans, the twelve included John Elias and John Bryan (1770–1856). Iorwerth C. Peate considered that 'the portraits of Evans and Elias were in such demand among the Welsh that it paid the Staffordshire potters to make them'.[23] Similarly, Horace Hird believes that John Bryan must have enjoyed sufficient popularity in his own lifetime for the Staffordshire potters to have considered him 'a sound commercial proposition'.[24]

The Christmas Evans figure shows the preacher with a Bible in his right hand, and his left arm supported by a pillar upon which are two other books. Like the other two figures, he is dressed in a swallow-tail coat, breeches, and stockings. In 1778 Evans was involved in a brawl which left him blind in the right eye, and from that time he was represented with this eye closed. Evans died in 1838, and so it is very likely that the figure was made as an *in memoriam*. The design for the figure of Elias also came from an engraving. The Elias engraving was by the Welsh portrait painter William Roos (1808–78) from a painting by Hugh Jones (1820– ?). The potter has modified the original image by adding to it a left forearm and hand, so as to represent Elias with the familiar accessory of a Bible. The contrivance is not altogether successful, as it leaves Elias holding the book in a rather awkward manner. What was even stranger was that this pose was uncritically incorporated into an engraving of Elias in *Enwogion y Ffydd*. As in the figures of Evans and Elias, the preacher has his name in raised capitals on the base, and is represented standing next to a pillar. The pillar, according to Hird, was a technical device 'frequently employed, as otherwise the figure itself would not be self-supporting'.[25]

Christmas Evans and John Elias were also commemorated in oil paintings by Roos. Evans was painted in 1835 at his home in Pwllheli Road, Caernarfon, and it was reputed that the artist was living next door to him at the time (**Plate 12**). The portrait of John Elias was painted at Fron, Llangefni in 1839. John Ingamells writes of these paintings that Roos had been 'alarmingly frank in his portraits of two thundering preachers, whose irrelevant physical blemishes are shamelessly underlined'.[26] Perhaps this Cromwellian principle of painting their portraits, 'warts and all', was adopted to stress the fallen humanity of these two great preachers, and so discourage excessive admiration. A former owner of these paintings, who was ignorant of the professions of the men depicted, thought the Evans portrait represented 'the physiognomy of a noted prize fighter. As to the other he would not hazard a guess.'[27] Painted portraits of notable Nonconformists were generally commissioned from painters in the locality of their congregations, and were the frequent and usual expressions of gratitude to faithful servants of God.[28]

The use of photography in the nineteenth century proved a serious challenge to the trade of the local portrait painter. The new medium provided results much more

31 '25 Independent ministers' (nineteenth century, second half), composite photograph by
John Thomas.

32 *74 o Enwogion y Pulpud Cymreig* ['74 Famous Men of the Welsh Pulpit'] (nineteenth
century, second half), composite photograph by John Thomas.

quickly and at a fraction of the cost of a commissioned oil painting.[29] It also made
possible multiple reproduction, so that authentic representations of Nonconformist
personalities could be owned by many admirers. Persuading the Nonconformists to
avail themselves of the virtues of photography, however, was another matter. The
Welsh photographer and Nonconformist John Thomas (1838–1905) recalled how on
a visit to Llanuwchllyn, Merioneth in 1873 he had to 'coax and reassure' many of the
old preachers and deacons to be photographed, to persuade them 'that his intentions
were perfectly harmless'.[30]

 Apart from the straightforward approach to photographing individual and group
portraits, Thomas also used a technique in which a large number of photographs,
usually miniature busts in oval shapes, were mounted together to form a composite
image. One such composition consisted of sixty-five Methodist ministers, another of
sixty-eight Welsh Wesleyan ministers with John Wesley in the middle. The idea of
arranging the images of saints in this way was not new to the history of religious art.
In the centre panel of the fourteenth-century *Triptych with Scenes from the Life of the
Virgin and Old Testament*, twenty-two miniature portrait busts occupy the upper third

33 Presentation trowel (1873), silver and ivory, Meifod Wesleyan
Chapel, Montgomeryshire.

of the picture. Each is framed by the tendril of a vine, which probably symbolizes
their state of abiding in Christ. A variation on this group portrait technique was
Thomas's '25 Independent ministers', assembled in such a way as to produce a
lozenge format (**31**). The formal aesthetic qualities of this image enable it to
transcend a merely honorific and documentary function. In his *74 o Enwogion y Pulpud
Cymreig* ['74 Famous Men of the Welsh Pulpit'] Thomas combines contemporary
portraits with photographs of engravings and paintings depicting preachers from
preceding generations (**32**). Among these portraits are those engravings of John
Elias, Christmas Evans, and Thomas Charles which appeared in *Enwogion y Ffydd*
(**29**). There is also a photograph of a painted miniature representing Daniel Rowland
by R. Bowyer (1758–1834), miniature painter to the king. Thomas also turned
these photographs of engravings and paintings into cartes-de-visite. Thomas's own
photographs did not escape translation into another medium; many of the photo-

34 Commemorative crockery (twentieth century, first half), china with transfer engraving,
Bethania Chapel (Calvinistic Methodist), Treleddyd Fawr, Pembrokeshire.

engravings in the *Enwogion y Ffydd* publication are derived from Thomas's studio portraits.

The occasion of a chapel's ministers and dignitaries retiring or resigning from office was usually accompanied by the presentation of a testimonial for their services. In a testimonial presented to Edward Griffith in 1897, a portrait of the minister appears on the first page. The succeeding pages carry tinted photographs of the house and landscape where he lived during his years of service (**Plate 4**). The testimonial comprised an illuminated address, sometimes extending over two or more pages. In such cases the address was bound in a leather book. Single-page testimonials were framed for hanging either in a chapel's schoolroom or in the recipient's home. The illuminated address represents the Nonconformists' tastes in decoration in microcosm. The floral motifs and foliate embellishments of the chapel interiors recur as a jungle of brightly coloured forms hemming in the testimonial on all sides. The testimonial itself was written after the manner of Gothic script with richly ornamented capitals.[31]

Chapel Life and History

Nonconformists commemorated not only the 'man of God' but also the 'house of God'. The founding of a new chapel was a momentous event in the life of a congregation, one that required at least two types of commemorative artefacts. At the opening of Havelock Street Presbyterian Church, Newport in 1895, the ceremonial laying of the foundation stone featured the presentation of 'a most tastefully designed and choice silver trowel with a carved ivory handle, the trowel

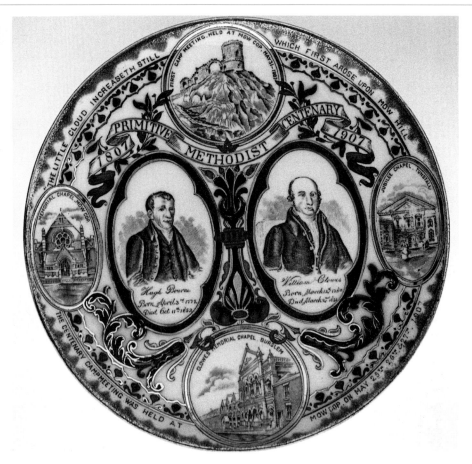

35 Commemorative plate: '1807 Primitive Methodist Centenary 1907' (1907), Wood and Sons
(Burslem), Staffordshire ware.

bearing a suitable inscription' and 'an ebony mallet with a similar white ivory handle'.[32] Engraved around the outside of the inscription would have been a foliate decoration available in a variety of designs (**33**). The main supplier of trowels and mallets at the turn of the century was the company of C. Henry Lea of Sheffield, which also manufactured ornamental keys to be inscribed and presented on the occasion of a chapel's opening ceremony.

The anniversaries of the opening of the chapel, together with those of the establishment of the chapel's Sunday School, and of the minister's term of office, were celebrated by special services of worship followed by tea. Many of the tea-services used for this purpose had, from the mid-nineteenth century onwards, the names and, sometimes, the portraits of chapels reproduced on them. One example shows a transfer print of an engraving of Bethania Chapel, Treleddyd Fawr, Pembrokeshire on both the cup and saucer (**34**). The custom reflected the Victorian distaste for plainness and the congregations' desire to use the image of the chapel as a corporate emblem. Like the family crest on the crockery and cutlery of the well-to-

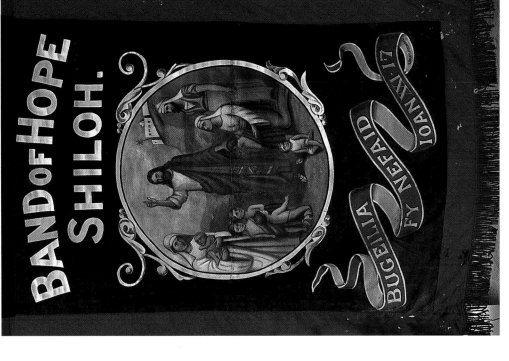

Plate 1 (left) Painted- and coloured-glass window (c.1889), by Swaine Bourne (Birmingham), Bethel (Baptist), Aberystwyth.

Plate 2 (right) Banner: 'Band of Hope' (twentieth century, first quarter), by E. Riley and Co, Leeds, oil on silk, Siloh (Calvinistic Methodist), Aberystwyth.

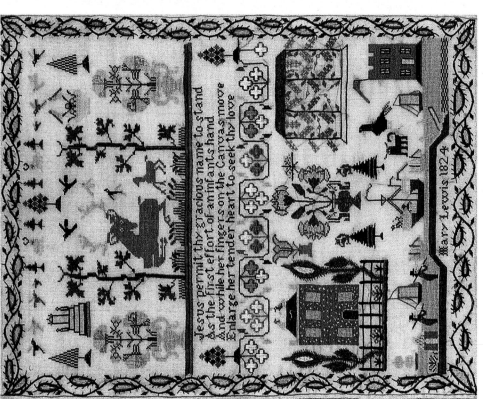

Plate 3 (left) Sampler: 'Jesus permit thy gracious name to stand' (1824), wrought by Mary Lewis.
Plate 4 (right) Illuminated address: Edward Griffith of Dolgellau (1897).

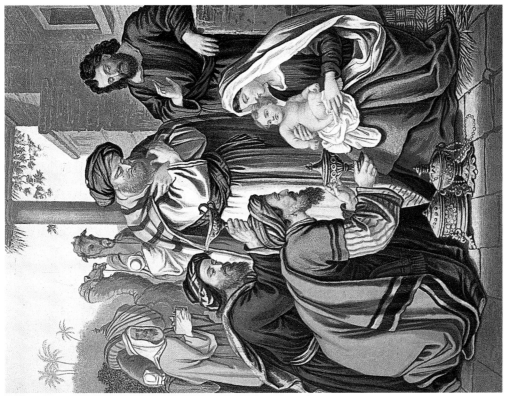

Plate 5 (left) Embroidered picture: Samuel and Eli (nineteenth century), Berlin wool-work.

Plate 6 (right) Bible illustration: 'The Nativity' (c.1874), lithograph, *Y Bibl Cyssegr-lan* (Edinburgh: Thomas

C. Jack; Cardiff: W. Berry and Co., [1874]).

Plate 7 (top) Glass painting: Nativity (nineteenth century), adapted from a Bible illustration by James Bateman (London).

Plate 8 Ornamental plaque with text: 'Praise Yea the Lord' (nineteenth century, first half), probably Staffordshire ware.

Plate 9 (top) *A View of the Baptizing in the River Ebbw, near New Tredegar, Monmouthshire* (1843), lithograph, by D. Morris (Newport) of a painting by J. F. Mullock.

Plate 10 Decorative Scripture text: 'Diarhebion xii.19' ['Proverbs xii.19'] (nineteenth century, last quarter–twentieth century, first quarter), from '10 Biblical Texts for Wall Decoration and Teaching', screenprint, printed by A. McLay and Co., Ltd. (Cardiff).

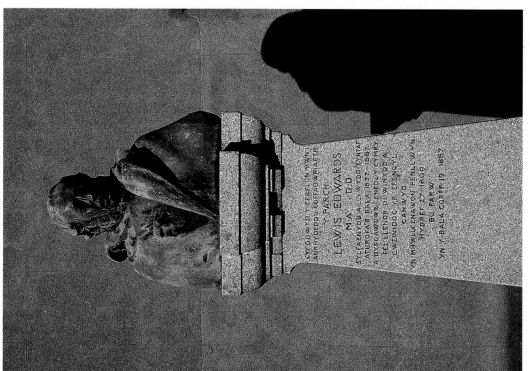

Plate 11 (left) *Lewis Edwards* (1912), by William Goscombe John, bronze, Penllwyn (Calvinistic Methodist),
Capel Bangor, Cardiganshire.

Plate 12 (right) *Christmas Evans* (1835), by William Roos, oil on canvas.

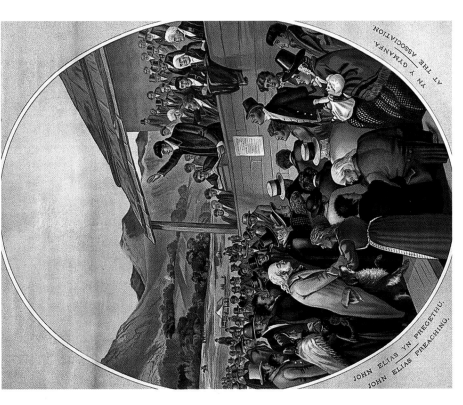

Plate 13 (left) *John Elias yn Pregethu yn y Gymanfa*/*John Elias Preaching at the Association*, colour lithograph
of a painting by Thomas Henry Thomas.

Plate 14 (right) Illustrated Bible: 'Y Bibl Cyssegr-lan' ['The Holy Bible'] (nineteenth century, last quarter),
lithograph, *Bibl yr Addoliad Teuluaidd* (Bristol: R. Reid, [n.d.]), title-page.

Plate 15 (left) Sunday School wall picture: 'Daniel in the Lion's Den/Daniel yn Ffau y Llewod' (nineteenth century, second half), lithograph by Butterworth and Heath of a painting by E. N. Downard (1862), printed by Kronheim and Co., London for the Religious Tract Society, London.

Plate 16 (right) Picture-cards: *Ffordd y Bywyd* ['The Way of Life'] (nineteenth century, last quarter – twentieth century, first quarter), lithograph, printed by Hughes and Son (Wrexham).

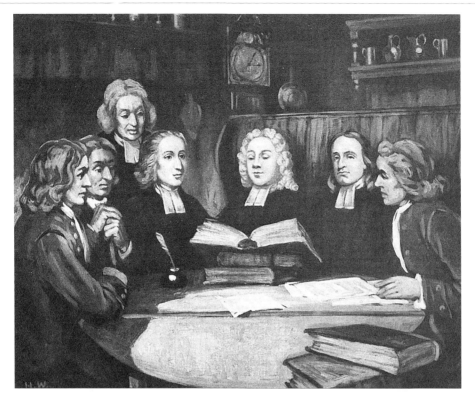

36 *Y Sasiwn Gyntaf (The First Association) 1743* (1912), lithograph of a painting by Hugh
Williams, printed by D. Salesbury (Prestatyn).

do, the emblem also conveyed prestige, nobility, and establishment, and was a means
of enhancing the public image of smaller and less wealthy chapels especially.[33]

Commemorative ware, such as the tea-services, is peculiar neither to
Nonconformity nor to the eighteenth and nineteenth centuries. The earliest example
is a mug celebrating the coronation of Charles II in 1660.[34] In the nineteenth century
the images of colliery disasters, battles, railways, and places of interest or of scenic
beauty were transferred on to pottery as memorabilia and souvenirs. Commemora-
tive crockery was also employed to memorialize the incidents that had shaped the
history of Nonconformity's connexions, denominations, societies, and auxiliary
movements. The Primitive Methodist Church, an independent Methodist church in
connexion with the official structure of Methodism, produced at least two
commemorative plates, one for the centenary of Primitive Methodism in 1907 and
another for the Primitive Methodist Connexion in 1910 (**35**). The church began in
Mow Cop, Staffordshire, so it is likely that the plates were made by the Staffordshire
potteries. The transfer prints show the founders of the church and their tombs,
memorial chapels, and a view of Mow Cop Hill. The plates would have been
distributed among Primitive Methodist churches in Wales.

Among the few commemorative prints of Nonconformist history was Hugh

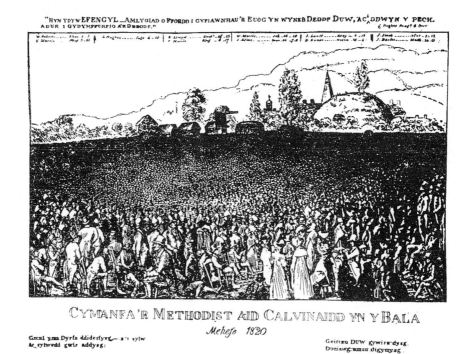

37 *Cymanfa'r Methodistiaid Calfinaidd yn y Bala* ['Association Meeting of the Calvinistic
Methodists at Bala'] (*c.*1820), by Hugh Hughes, woodblock engraving.

Williams's *Y Sasiwn Gyntaf (The First Association) 1743*, printed by D. Salesbury
Hughes of Prestatyn in 1912, which depicts a meeting held during the formative
years of the Calvinistic Methodist Church (**36**). The picture shows a darkened
interior with six figures around a table and one standing, the central figure presiding
over a Bible being the English Methodist evangelist George Whitefield (1714–70).
The illustration was reproduced commercially as a colour lithograph for which an
advertisement appeared in the Calvinistic Methodist newspaper *Y Goleuad* ['The
Light'] in 1912. [35]

The meetings of the Welsh Calvinistic Methodist Association held annually in
Bala during the nineteenth century were commemorated by at least two prints. The
earliest was *Cymanfa'r Methodistiaid Calfinaidd yn y Bala* ['Association Meeting of the
Calvinistic Methodists at Bala'] which depicts the many thousands that gathered in
the June of 1820 at the open-air meeting to hear John Elias (considered to be one of
Wales's greatest preachers) and others (**37**). It shows the motley crowd of serious and
attentive listeners, the listless and idly curious, and town and country people. The
print also includes various pious mottoes, a list of the meeting's preachers and the
biblical texts on which their sermons were based. *John Elias yn Pregethu yn y
Gymanfa/John Elias Preaching at the Association* by the Welsh artist and Nonconformist
Thomas Henry Thomas (1839–1915) is a more recent representation of the subject

which centres around the covered platform from which the preachers addressed a crowd of what would have been recognizable types of class and background, including a mother in traditional Welsh costume, and a young girl pleading with her father, presumably, to heed the preacher's message (**Plate 13**).

Church Ordinances

For the Nonconformists the memorial of the covenant between God and His people was no longer a pillar of stone but a supper of bread and wine (1 Corinthians 11:23–6) (see Chapter 1). The Lord's Supper is the central and most poignant memorial associated with chapel life, and one of only two ordinances which Nonconformists observe, the other being baptism. The latter spawned a variety of artefacts to commemorate the occasion. The baptism or christening of infants, practised by the Independent and Methodist churches, was memorialized in christening cups and spoons which, like the presentation trowels and mallets, could be purchased from a variety of ecclesiastical suppliers. Baptists believe that 'Those who do actually profess . . . repentance towards God, faith in and obedience to our Lord Jesus, are the only proper subjects of this ordinance' and, consequently, refrain from baptizing infants.[36] The only commemorative artefact associated with the baptism of adults was usually a certificate of baptism. However, a baptism in the River Ebbw, near Tredegar Park, Monmouthshire 'on Lords Day, October 22nd 1843, when nine persons were immersed according to the rites of the New Testament, by Mr T. Morris, Minister of the Baptist Temple, Newport, in the Presence of some thousands of spectators', was commemorated in the form of a chromolithographic print depicting the scene. The print was published by D. Morris of Newport and probably intended for the consumption of local Baptist congregations (**Plate 9**). The picture is accompanied by a number of quotations from both the Bible and Bible commentators justifying the ordinance of believers' baptism by total immersion. Thus, like the Sunday School banners depicting the baptism of Christ, the print was also a forceful agent for disseminating Baptist doctrine. The print, like those of the Bala Association meetings, mentioned above, features a throng. The image of a large crowd would have been instrumental in promoting a sense of the denomination's numerical strength and of the immense public interest in their cause.

The development of mechanical reproduction during the nineteenth century meant that images such as this could be printed in virtually unlimited numbers. The vast number that still survive prove that this potential was exploited to the full. However, as has been shown, the variety of original images from which the reproductions were derived was sometimes very limited. The reason for this was, possibly, the scarcity of original images of any real quality, and that the Nonconformists saw no reason to commission new images when existing ones sufficed – an expression either of Nonconformist functionalism or stringent thrift.

Consequently, the few that were credible representations of their subjects were constantly reiterated and transformed as adjuncts to books or as the basis of representation in different media. For Nonconformists these images were the currency of appreciation. Whether serving as a memorial, memento, or means of conferring honour, the artefacts were instrumental in promoting a consciousness of history. Like Israel's stones, they provided a monument to posterity, a perpetual witness to the acts of God in the lives of men and in the institutions He had raised.

4

Art in the Service of Teaching

We know that Art was not encouraged among the Jews in the ancient days. There were special reasons for this. The Jews were idolatrous in tendency, and lacked the spiritual discernment to distinguish between the symbolic and the real, and thus they were forbidden to make themselves 'graven images or any likeness of anything' . . . Art became the source of idolatrous conceptions and practices, and even in the early Christian Church, and in the Church of Rome to-day, there was, and is, a similar tendency; but to the measure that we are able to accept Art as descriptive or illustrative of sacred truths, and not as having any intrinsic spiritual efficacy or worth, to that extent only does it . . . become a valuable aid.

David Davies, *Sacred Themes and Famous Paintings*[1]

In his *Institutes* Calvin wrote that paintings and sculptures representing biblical events could be legitimately employed as a means of teaching. This was with the proviso that they were neither set up in churches and worshipped nor used as a substitute for preaching and the sacraments. Calvin had insisted that the propagation of the faith was to be in accordance with the scriptural ordinance, and this meant preaching and teaching the Word of God (Mark 16:15). Likewise, preaching and teaching were to be the Church's pre-eminent means of religious instruction. Thus art was of value as a didactic tool only when used in subservience to the written and spoken Word of God, a principle which regulated both the scope of art's usefulness and the range of images that could be called upon.

It was in this spirit of conditional acceptance that Nonconformity pressed both high and applied art forms into the service of teaching. Since Nonconformists did not believe that art could induce faith in a person, it served only to adorn and illustrate the 'word of faith' and to help press home the lessons derived therefrom. The use of art in the service of teaching was, in this way, not a substitute for written or oral instruction. Images were intended to be subservient to and dependent upon the authority of the Bible, their message was to be always construed according to an understanding of Scripture, and their value was deemed to be in proportion to their faithfulness to Scripture. For this reason, they were rarely seen without the appendage of a Bible verse or reference, or a preacher's interpretative commentary.

Sermons in Oils

This is particularly evident in the way in which art was employed in the service of preaching. During the late nineteenth and early twentieth centuries, a number of Nonconformist ministers adopted famous paintings to serve as homiletic illustrations. In a climate where it was felt that Christianity should relate to the needs of life in the modern world rather than confining itself to exclusively spiritual or religious themes, some felt that the preacher would receive a more favourable hearing from the man of the world if he could adorn his discourse with illustrations not only drawn from everyday life but also demonstrating a measure of cultural erudition. In response to this, books of ready-made sermon illustrations were compiled to provide preachers with a supply of pithy anecdotes for every occasion, including a selection of parables drawn from the lives and works of artists past and present.

Due to the moralizing content of the Victorian narrative genre, many paintings were easily adapted to this purpose. The work of G. F. Watts (1817–1904), William Holman Hunt, and William Frith (1819–1909) were frequently conscripted to illustrate sermons and articles in the denominational journals. For example, in 1885 the Welsh preacher David Davies (1849–1926) delivered a series of sermons illustrated by works of fine art at Regent's Park Baptist Chapel, London, where he was then minister. Like Calvin, he believed that art could render a service 'to the cause of genuine religion by the illustration of Scriptural incidents and of Christian truth'.[2] It appears that, in keeping with Calvinistic doctrine, neither the paintings nor their reproductions were brought into the chapel. The congregation had to be content with a verbal representation from Davies's own description of them, though the paintings, having been popularized in the form of photo-engravings, would probably have been familiar to many Nonconformists. The service that art could render to Christian teaching, Davies believed, was as an aid to a clearer understanding of 'the significance of Scripture narrative or truth'.[3] It was therefore necessary that the paintings chosen for this purpose represented faithfully the facts of the Bible texts.

Davies's concern for veracity was one of the reasons for his obsessive disparagement of the halo or nimbus. However, Davies was not averse to symbolic conventions as long as they were consistent with the record of biblical history. For example, he was not against the suggestion of a nimbus if it was also achieved by some natural device. This was done with 'great tact' in Holman Hunt's *The Shadow of Death* (1873). Here, the nimbus is suggested by placing the arch of one of the windows behind Christ's head.[4] The device also centres the spectator's attention on the figure of Christ rather than on Mary kneeling to His left. This de-emphasis of the figure of Mary was a direct result of Reformation doctrine. For the Protestants she was not the worshipful and sinless Madonna of the Roman Catholic tradition, but rather a poor and lowly woman of Nazareth. Davies credits Raphael (1483–1520) with having initiated a more appropriate representation of Mary by

ridding her of crown and jewels. Raphael, 'nevertheless, failed to devote his genius to the faithful representations of facts. Mary is represented as an Italian mother.' For this reason Raphael and his successors could not be accepted 'as Christian teachers, or their paintings as helpful to the study of Scripture'. Painters such as Holman Hunt and the Pre-Raphaelite Brotherhood constituted a more acceptable form of Protestant art. Their works, he considered, were more consistent with biblical facts and truth, and as such should be readily embraced by Protestants as acceptable means of teaching and 'aids to devotion'.[5] This aid would have been not in terms of directing believers' thoughts to the images themselves, as in the case of icons, but of pointing back to the Word of God from which they had been derived. The usefulness of such works of fine art could be enhanced by 'the co-operation of the Christian minister'.[6] In the context of Davies's sermons this was expressed in a spoken exegesis of each painting's content, and took the form either of constructing a narrative around its figures and accessories or else of reading into the picture scriptural principles and ethical lessons.

In 1915 the *Baptist Record* published a series of articles under the heading 'Picture Talks to Boys and Girls' which further demonstrates this practice. They were written by Evan Williams who, like Davies, had once been the minister of a chapel in London. (Each of these men, unlike their colleagues in Wales, had therefore had the opportunity to see 'great' art, and it seems as likely a reason as any for their basing some of their sermons on paintings.) For example, Williams accompanied a description of the painting of William Quiller Orchardson's (1832–1910) *Napoleon on Board the 'Bellerophon'* with a commentary which invests it with moral didacticism – the downfall of nobility. The painting, he believed, was meant to teach that 'the victories of selfishness are worthless', a lesson derived from an understanding of the past and future events surrounding the historical moment depicted. A spiritual significance was also imparted to the picture by contrasting Napoleon's career with Christ's ministry on earth: 'Napoleon sacrificed the world to his ambition; Jesus sacrificed Himself to the world. The result is that Napoleon is remembered and despised, whereas Jesus is remembered and loved.'[7] For those whose appreciation of the painting had been informed by reading Williams's narrative, the image would thereafter have a parabolic significance.

Paintings which were either used as the basis of sermons or articles, such as those by Williams, or referred to in passing in sermons on other topics, often served only as a starting-point for a discourse which usually exceeded the bounds of the incident depicted. At other times the painting's immediate and intended meaning was glossed over, its subject-matter becoming transfigured by allegorical, religious interpretation. Like the object-lesson in Sunday School education, paintings were used as a mnemonic device to recall the lesson associated with it every time it was seen. Consequently, even paintings that did not possess a covert or even remotely religious subject could be infused with spiritual significance.

38 'Adoration of the Magi' (nineteenth century), engraving by H. Cook after a painting by
Paolo Veronese, *Y Beibl Teuluaidd Cynnwysfawr* (London: Blackie and Son, [n.d.]).

Illustrated Bibles

Davies had considered that Italian Renaissance art was inexpedient to the service of
Christian teaching not only because of its historical inaccuracy but also because of
its propensity to propagate Roman Catholic dogma. On the rare occasion when
either Italian or Roman Catholic art was used to illuminate a sermon, its error was
revealed and censured by the minister's discerning exposition. However, famous
paintings by Italian masters illumined Scripture independently of ministerial
guidance in the form of photo-engravings reproduced in the nineteenth-century
illustrated Welsh Bibles.

The illustrated Bibles were printed in a large quarto size: some were designed for
use in the home and included an ornamented family register for recording births,
marriages, and deaths, while others served as pulpit Bibles (**Plate 14**). Five of the
illustrated Bibles contained annotations by the Welsh preacher Peter Williams
(1723–96), some of whose comments on the first chapter of John's Gospel were
considered heretical.[8] Heresy was also perpetrated more insidiously in pictorial form.
This was a result of illustrating the Bible with images originally used by the Roman
Catholic Church, and whose theological content was not consistent with Noncon-
formist doctrine. An instance of this appeared in a Peter Williams Bible published by
the London Printing and Publishing Company. Here the offending image is an
engraving of the Apostles Peter and Paul, made from a painting by Flemish painter
Peter Paul Rubens (1577–1640). Peter is represented with a key in either hand,

symbolizing the keys to the kingdom of heaven. A cherub reclines on the ledge of a building above and behind his left shoulder. Among the artefacts it carries is a cross with three crossbars; this triple cross is used exclusively by the Pope. The combination of both objects symbolizes the Roman Catholic doctrine of the primacy of Peter as head of the Church, and the Roman pontiffs as successors of Peter in that primacy. A further heresy was propagated in a Welsh Bible printed by Blackie and Son of London, published towards the end of the nineteenth century. In the engraving of Paolo Veronese's (c.1528–88) *Adoration of the Magi* (1573), Mary is adorned with a nimbus (**38**). The convention pictorially marks her out for special attention, and symbolically endows her with divinity. Both the emphasis and ascription would have been considered 'idolatrous conceptions' by Nonconformists.[9] Whether the majority of Nonconformists recognized these doctrinal aberrations in pictorial form, however, is a different matter. It is unlikely that the grass-roots believers were conversant with the symbols of Roman Catholic art, and these images would not therefore have been considered an assault on their beliefs.

Neither the Rubens nor the Veronese engraving is a literal representation of historical events. The nativity in the Veronese, for instance, is set against the background of classical architecture. (The column is a symbol of the Christ-child's future passion.[10]) Without understanding the symbols of Roman Catholic art, this incongruity of historical elements is difficult to rationalize. For the Nonconformists, such images would have been more of a stumbling-block than a stepping-stone to understanding Scripture. Roman Catholic images were probably allowed in the Bible because of the lack of Protestant equivalents.

Together with these images were bound illustrations of paintings from a distinctly Protestant source. In the Blackie and Son version of the Bible are several engravings after paintings by John Martin (1789–1854). These engravings first appeared in 1844 in an English version entitled *The Imperial Family Bible*. Martin's fervent denunciation of the papacy, as seen in his painting of *The Last Judgement* (1853), had probably guaranteed his work a wide and frequent exposure in Protestant circles. His faithful rendering of architecture and attention to detail endow the engravings with an awesome sense of reality, and this in turn endorses the historicity of the biblical events.

The Bibles not only made bedfellows of different Christian theologies but also of different visual media. In a single Bible, engravings were often accompanied by colour-lithographic illustrations of a variety of styles and quality. This would suggest that the images had been gleaned from a number of sources with little consideration for consistency. A large proportion of these sources would have been existing English Bibles, the many illustrations with captions in English testifying to this. Apart from supplying a devotional aid, the illustrated Bibles introduced high art to the Welsh people and exposed them to great paintings that they might not otherwise have seen. They must therefore be considered notable contributors to what little exposure the Welsh had to great works of art (see Chapter 5).[11]

39 'Cristion wrth y Groes' ['Christian at the Cross'], engraving,
Taith y Pererin ['Pilgrim's Progress'], (Denbigh: Thomas Gee,
1860).

Devotional Books

Apart from the Bible, by far the most popular book of Christian teaching has been
John Bunyan's (1628–88) allegory *The Pilgrim's Progress* (1678). The first Welsh
translation to appear in the nineteenth century was published in 1805 by J. Daniel of
Cardiff. During the years that followed up to 1907, a further thirty-four Welsh
editions were published by companies in Wales, England, and Scotland. The book's
imaginative and descriptive passages lend themselves readily to the art of the
illustrator. At least a quarter of the Welsh editions contained several representations
of key events in the story. The first illustrated version appeared in 1819, printed in

40 'So the Post Presented Her with a Letter', engraving by J. C. Armytage of a drawing by
J. M. Wright, *Taith y Pererin* (London: James S. Virtue, 1867).

Liverpool by Henry Fisher, with illustrations drawn by W. M. Craig and engraved by
T. Wallis.

The opening image shows 'Christian Losing his Burden at the Sign of the Cross',
one of a number of incidents which was represented in almost all the illustrated
editions (**39**). Christian is depicted in nineteenth-century costume, symbolizing the
relevance of his experience to the contemporary generation. The incident takes place

in the historic setting of Calvary Hill, outside the city walls of Jerusalem. This particular incongruity of historical elements would no doubt have been excused, as the allegory was the recounting of a dream. The wooden cross is represented more as a symbol than as an actual crucifixion gibbet. This tendency is seen in all the Welsh editions that include an illustration of this incident. In a number of editions the symbolic form is maximized, the cross appearing as either a simple outline or a flat abstract shape, like a gravestone. To have depicted a crucifix might have suggested that Christian was either adoring the image or else receiving a mystical vision of the suffering Christ. Both practices were common in Roman Catholic tradition and iconography. In the context of Bunyan's allegory, the cross is merely the symbol of God's power unto salvation (1 Corinthians 1:18). The illustration of angels in these editions goes against Calvin's restrictions on representation, that only that 'which can be presented to the eye' should be depicted.[12] In the 1867 edition printed in London by James S. Virtue, an angel is shown delivering a letter to Christian's wife, Christiana. The composition of the scene is reminiscent of certain Annunciation paintings of the Italian Renaissance (**40**). The representation of the angel and the costume of the characters is also after the manner of this period.

The influence of Italian art brings with it the unavoidable associations of papal patronage and ideology. This has made some of the engravings inappropriate for what is essentially a Puritan classic. The fine art sophistication of the images is also out of keeping with the simplicity of Bunyan's literary style. In the editions printed by the Welsh publishing companies the illustrations are less refined, and at times crude, although much more in sympathy with the spirit of Bunyan's story. In a publication by G. Jones of Bala in 1856 the principal character is dressed in the attire of Bunyan's day. This style of clothes was later adopted in an English version of the book, retold for children by David Davies.[13] Davies, being consistently critical in his choice of imagery, spent ten years looking for an artist to illustrate the story. The artist who finally met with his standards was W. R. Warry, whose efforts, Davies believed, made the edition the most faithful and graphic depiction of Bunyan's characters ever published. The virtuous characters of the story are dressed in the distinctive garb of the Puritans, while the disreputable are generally depicted as Cavaliers.

As in the case of the illustrated Bibles, the images of the Welsh publications would appear to have been drawn from a number of English versions. For a publication of 1848 by H. Humphreys of Caernarfon, two separate sources of illustrations had been drawn upon. The style of execution and manner of representation in each are distinct, so much so that there is no correspondence between the characters in one set of illustrations and their counterparts in the other. Since these images bear little relation to one another, their meaning must be read in conjunction with their respective texts. They thus function as illustrations to particular incidents in the text without maintaining coherence visually within the story. This lack of continuity was probably the result of purely practical considerations. The Welsh publishers may have wished to illustrate more incidents

41 'Martin a'i Chwaer Fach' ['Martin and his Little Sister'],
engraving, *Trysorfa y Plant* (1862–4).

than were possible with the images from any one particular source. Consequently
they had to resort to other books, whose styles were different, to make up what was
lacking.

Bunyan's allegory translated profound Christian doctrine into a rich, imaginative,
and accessible drama. For this reason it was often used in the teaching of the young.
Nonconformists recognized the appeal images had for children, how they could at
times convey ideas more potently than the written or spoken word. For this reason
visual aids were readily used in a child's religious instruction from the mid-nineteenth
century onwards. Children's literature was liberally furnished with illustrations of
biblical characters, events, and truths. A typical example of this was *Trysorfa y Plant*
['The Children's Treasury'], first published by the Calvinistic Methodist Church in
1862. The magazine shows how images were used to transmit the moral, spiritual,
and cultural values of one generation to its progeny. Every issue abounds with
scenes of domesticity, filial devotion, and the camaraderie of youth. By these
examples, family and neighbourly loyalties were commended, and their practice
encouraged. Morality was also taught through images of children perpetrating
misdemeanour and receiving their just deserts. These were contrasted by images
extolling the rewards of good conduct and wholesome activity. One practice often
recommended for emulation was that of temperance, a cause for which Methodism
had been chiefly responsible. Images showed anthropomorphic beer bottles being
derided or warded off by children.

Children's devotional life was fostered through images of infants kneeling

42 'Mab y Dyn' ['Son of Man'], engraving after Raphael's *Madonna della Sedia* (1514–15),
Trysorfa y Plant (1873).

together in prayer, or absorbed in conversation over an open Bible (**41**). Illustrated
stories from the Old and New Testaments provided an attractive introduction to the
Scriptures. These included portraits of Old Testament saints and scenes from the life
of Israel, Christ, and the early Church. The many accessories of Old Testament
worship were also realized in vivid drawings and explanatory diagrams. Their
ponderous descriptions in the Bible became, in the language of line and tone,
impressive artefacts of divine design and human skill. The magazine also included
short biographies of great Welshmen of the faith, which were illustrated with
portraits and scenes from their lives. The education of children was not, however,
confined to affairs of personal and national piety. An awareness of wider cultural
matters was promoted through illustrations of famous paintings, places and people,
and scenes from far-off lands (**42**). By these means missionary interest was
encouraged.

Illustrated Sunday School Material

In the periods of social reconstruction which followed the First World War, the denominations stressed the importance of children, who were the future members of society and, more particularly, of the churches. While the chapels had grown in splendour since the middle of the nineteenth century, the Sunday School rooms, which were either attached or adjacent to the chapels, had remained cheerless and dreary.[14] There was general agreement that if the chapels were to compete with the standards of provision and decoration characteristic of secular schoolrooms and woo the young away from such enticements as Sunday cinema and other distracting amusements, the Sunday Schools would need to be made more efficient and thoroughly up to date in both teaching methods and materials.[15] John Adams's influential *Primer on Teaching with Special Reference to Sunday School Work*, published in 1903, had commended the use of pictures in the education of children, in the belief that the child thought more in concrete than in abstract terms, and that the contemplation of an action represented in a picture would intensify their desire to perform that action.[16] In keeping with Adams's recommendations, J. H. Saxton enthused in the *Baptist Record* in 1926: 'I would have brighter schoolrooms. I would have endless pictures. All the flowers would bloom for us, and all the best picture books should come into our schools . . . I would have nearly all the teaching done through the medium of picture, parable, and map.'[17]

The new visual aids to education such as lantern slides were requisitioned 'to impress on the child mind facts concerning temperance, nature, and the habits and customs of other countries and climes'.[18] The National Sunday School Union supplied a large selection of these, depicting scenes from the Old Testament, the Holy Land, and the ministry of the Apostles, together with illustrations of the life of Christ which they were assured were by the 'Best Artists', including a large selection of Gustav Doré's (1832–83) biblical engravings. In retrospect, however, some Nonconformists came to see that their expectations regarding the efficacy of lantern slides in child education had been misguided, that they had made the mistake of thinking that the presentation of images alone would be sufficient to educate: 'A lantern can only drive home lessons already taught with some amount of labour . . . Even in the lantern lecture the value of it consists not in the pictures displayed, but in the oral instruction accompanying them.'[19] What the slides lacked was the guidance of an interpretative commentary like that which accompanied paintings used as sermon illustrations.

Illustrated materials such as wall pictures and picture-cards were also produced under the auspices of the Sunday Schools. Good examples of the former were the brightly coloured wall pictures published by the Religious Tract Society, London, and those by Thomas Nelson of London for the National Sunday School Union to accompany the British Graded Bible Lesson Courses which many Sunday Schools taught.[20] These were hung in Sunday School rooms not only to illustrate the scenes

43 Certificate: 'Calvinistic Methodist Sunday School Union, Llangollen District', printed by
the Educational Publishing Company, Merthyr Tydfil (*c.*1900s).

in which the Bible stories were set, but also in an attempt to make the environment
of instruction more attractive to the children and thereby keep them in attendance
(see **Plate 15**, for example). Concerning the picture-cards, Thomas Jones explained:
'Single verses, drawn freely from all parts of the Bible, and printed on cards with
coloured borders were given to us at each attendance, and a larger card in return for a
number of them, and then a certificate for framing as a final reward. The framing of
biblical texts and proverbs describing virtue, and admonitions to redeem time, for
there were but sixty minutes in each hour, was common.'[21]

Certificates were also given for committing to memory passages from the Bible,
devotional books, and hymns. Like the illuminated address, a profusion of foliate
forms were used to decorate their borders, and unfurled scrolls, like those on the
chapel walls, displayed the title of the certificate of Sunday School Union. A
certificate of 1910 was produced for the Llangollen district of the Calvinistic
Methodist Sunday School Union by the Educational Publishing Company, Merthyr
Tydfil. It includes a reproduction of an engraved portrait of Thomas Charles and
photographic portraits of the district's preachers and chapels (**43**). A number of the
certificates incorporate the image of an eye, representing the eye of God, sometimes
enclosed by a triangle, its three separate but interlocking sides symbolizing the
paradox of the three distinct persons of the Trinity as one God. The symbol is of
Roman Catholic origin, and a notable concession on the part of Nonconformists to
a visual representation of the Godhead.

A series of '10 Biblical Texts for Wall Decoration and Teaching' were printed by

Trysorwch i chwi drys-
orau yn y nef.
MATH. 6, 20.

Gwna fi fel un o'th
weision cyflog.
LUC 15, 19.

Dyro i ni heddyw ein
bara beunyddiol.
MATH. 6, 11.

Cofia yn awr dy Greawdwr
yn nyddiau dy ieu-
engctyd. PREG. 12, 1.

Efe a'm tywys gerllaw y
dyfroedd tawel.
SALM 23, 2.

Deuwch ataf fi . . . a mi
a esmwythaf arnoch.
MATH. 11, 28.

44 Picture-cards: *Ffordd y Bywyd* ['The Way of Life'] (detail).

A. McLay and Company of Cardiff, probably at the end of the nineteenth century.
The style of their typographic forms is akin to the painted texts of the chapel
interiors; the arrangement, however, is distinct in that successive words or lines are

often treated in a variety of faces and colours (**Plate 10**). This variation is in most cases completely arbitrary, that is, governed solely by decorative considerations and not by any rationale suggested by the text. In other instances the typography remains uniform with the exception of a key word that is printed in a more conspicuous face.

The arbitrary combination of decoration and text can also be seen in three of a series of four composite images published by Hughes and Son of Wrexham. In *Diarhebion i'r Plant* ['Proverbs for Children'] eighty-four Bible texts are accompanied by scenes of butterflies in fields, and of boats in stormy seas or anchored by the shore of a still lake. Since these images have no direct reference to their captions, they cannot be considered illustrative in the explanatory sense of the word. It is likely that the whole image was intended to be cut up into its components and distributed to the Sunday School pupils. The images would have attracted the child's attention to the cards and thereby to the texts. Many of them are rich in detail and thus capable of holding their attention and undergoing frequent review. The more a child looked at the image the more the text would have been instilled into his or her memory. A recollection of the image would bring with it a simultaneous remembrance of the text. In this way the image served as a mnemonic device. Although the images were only decorative adjuncts to the texts, they were not all devoid of religious meaning. The images of a boat in troubled seas and in a quiet harbour were used as metaphors for a believer's journey through life's difficulties and for his or her heavenly abode. The symbolism was often expressed in Nonconformist hymns and preaching.

The composite picture-card *Ffordd y Bywyd* ['The Way of Life'], printed by Hughes and Son of Wrexham, shows how images were used to elucidate the texts (**Plate 16**). As the variety of images is considerably less than the number of texts, a single image appears above several different captions. The interpretation of the image would therefore be modified in each instance; for example, in conjunction with a verse from Luke, chapter 15, the image of a young man bowing to his senior is understood to represent the prodigal son repenting to his father (**44**). However, in the context of a verse in Psalm 32, the young man takes on the identity of a penitent sinner, and the prodigal's father becomes an anthropomorphic figure of God. In the story of the prodigal son, the young man and his father are likewise analogies for a repenting sinner and a forgiving God. In this way, the image, in conjunction with both texts, completes the parable.

Just as Nonconformity's use of famous paintings to illustrate sermons did not induce the cultured middle class back into the pews, so its efforts to keep up with the increased use of visual aids in education generally, and to use them as a pictorial carrot to entice the young away from Sunday excursions, games, and cinema, failed to stop the decline in Sunday School membership after the First World War. By the 1920s numerous reasons had been suggested as to why 'the fish have not risen to these flies'.[22] Some considered that the responsibility lay with a lack of funds to pay for adequate visual materials and the dearth of Sunday School teachers, which were the further consequences of the decline in chapel membership and revenue.[23] Others concluded that the churches had leaned too much upon methods and adventitious

aids, and would attract adults and children again only when the fundamental doctrines of the Bible (such as the inspiration and infallibility of Scripture, and the divinity of Jesus Christ), the primacy of preaching, and the efficacy of the gospel message (convictions which many ministers had abandoned due to the influence of modernist or liberal theology) were reasserted.[24] Thus spiritual prosperity and numerical growth would not be brought about by the service of art but by the churches being as faithful to the 'sacred truth' as some ministers had required art to be.

5

Nonconformity in the Service of Art

I suspect that if the Methodist schism had never occurred, or if the Nonconformists had been less obsessed with the fear of Popery and sacerdotalism, the culture of modern Wales might have suffered less from that imperfect sense of visual beauty which by common consent is its chief defect.

<div align="right">H. Idris Bell, 'The Church in Wales and Modern Welsh Cultural Life'</div>

[Ben Bowen Thomas] helped to a explode a myth, namely that Nonconformity in Wales has been responsible for stultifying the development of the arts in our country; that somehow or other Wales would have been dotted with art galleries, had it not been for John Elias and Christmas Evans.

<div align="right">Lord Cledwyn of Penrhos,

Celfyddyd a'r Cymro Cyffredin/Art and the Average Welshman[1]</div>

Certain writers at the beginning of the twentieth century blamed Nonconformity for the absence of a substantial visual culture in Wales. It was alleged that, as a consequence of the doctrine forbidding the use of images in worship, Nonconformity possessed and infected the Welsh people with a 'foolish timidity as regards art in general', and had, thus, 'retarded the development' of art appreciation in Wales.[2] The accusation was based on the belief that 'in accordance with Calvinistic traditions . . . the appeal of art in general was neglected and despised as a handmaid of Religion'.[3] However, it was shown in Chapter 1 that, according to Calvin's teaching, art was to be readily embraced as a gift from God, and the only restriction on its use was that it should neither be used as a means of worship nor set up in a church. Apart from this, it could legitimately be employed in the service of religion as a means of teaching and exhortation. Accordingly, Nonconformity neither neglected nor despised art, but accepted it as a handmaid to religion, not only as a means of decorating the chapel and home (even though Calvin had expressed considerable reservations regarding the legitimacy of 'ornament' in churches), but also as a means of commemoration and teaching. It remains to be established whether Nonconformity was responsible for the neglect of art and its appreciation by the Welsh in general.

Art in Wales: The Neglect of the Cause and the Cause of Neglect

The neglect of art by the Welsh can be inferred from census returns for Wales and Monmouthshire in 1851, which show that out of a population of 945,914 as few as 136 were artists. The census also records only fifty other persons involved in fine-art related occupations, producing pictures and engravings, carvings and figures, and medals and dies. In contrast, musicians (not including music teachers), makers of musical instruments, and persons with some other musical connection, numbered 320; with an additional sixty music teachers, almost twice the number of people working in fine art during the same period. In comparison to the number of people engaged in the production of literature, the visual arts fared even worse. Authors, including editors, numbered sixty-four, with 903 involved in the occupations of printing, bookbinding, book-selling, and publishing – five times the number of those working in art-related occupations. The total does not include the many bards and poets in Wales who were not given occupational status in the census. A numerical breakdown of the above-mentioned information is given in the table below.[4]

Occupation	Under 20 years		20 years and upwards	
	Males	Females	Males	Females
Artists	6		128	2
Persons engaged in pictures and engravings	2		32	1
Persons engaged in carvings and figures		1	5	3
Persons engaged in medals and dies			6	
Persons engaged in music	52	4	247	17
Music masters and mistresses	3		37	20
Authors	10		54	
Persons engaged in books	207	9	653	34

Over forty years passed after the census was taken before a concerted attempt was made to account for and remedy Wales's neglect of the visual arts. Among those who endeavoured to address the deficiency were prominent Nonconformists, including Tom Ellis (1859–99), the Welsh language and literature enthusiast, pioneer of Welsh nationalism in Parliament, and 'a sturdy Nonconformist and a deacon at the local Methodist Chapel at Cefn-ddwy-sarn',[5] Thomas Henry Thomas, and the Nonconformist ministers Iona Williams, D. Cunllo Davies, and T. Mardy Rees. The state of art in Wales was first brought to public attention in an article of 1895 by J. Clarke, art master at the University College of Wales, and by Hubert Herkomer (1849–1914), painter, designer, and one of the most prestigious supporters of Welsh

art, in an address to the National Eisteddfod in that year and in an inaugural speech Herkomer delivered to the Liverpool Welsh National Society in 1897. Both authors agreed that the state of visual art in Wales was 'decidedly unsatisfactory', a judgement derived from the inconsiderable role art played in the national culture.[6]

Clarke believed that the notable lack of enthusiasm for art among the Welsh people should be blamed on the Nonconformists' ancestors, the Puritans. In putting into practice the Calvinistic doctrine forbidding the use of images in worship, the seventeenth-century Puritan reformers dealt a severe blow to the heritage of art and craft in Wales. In their bid to stamp out iconolatry (the worship of images) they destroyed an incalculable number of shrines, wooden images, statues, and wall paintings which had flourished in late-medieval Wales:

> The blow given to art generally by the suppression of the monasteries, confiscation of their endowments, and the other outrages of the Reformation spoilers, which to wealthy England was not so fatal, killed off most of the existing art in Wales; and since that time her art history is nearly blank. Thus, she lacks the incentive to art enthusiasm produced by the possession, observation, and study of monumental works of art.[7]

The desecration of the nation's visual heritage, Iona Williams suggested, stemmed from the Puritans' confusion of art with the idolatry of the Roman Catholic Church. This confusion, he wrote, 'still exists and hinders the progress of art', implying that the development of art in Wales at the beginning of the twentieth century was being thwarted by some Nonconformists at least who were perpetuating a distrust of art and an iconoclastic mentality.[8] In Clarke's opinion there was an urgent need both to counter the effects of the 'Reformation spoilers' and to cultivate 'a more appreciative public' by the acquisition of great works of art and the establishment of museums and art galleries – a proposal echoed by Williams.[9]

While they considered Puritanism to have been the chief cause of Wales's neglect of art, neither Clarke and Williams, nor for that matter many other commentators on art in Wales during the late nineteenth and early twentieth centuries, believed it to have been solely responsible for this ill. Furthermore, no one thought that the condition would be remedied simply by importing and exhibiting great works of art. For example, Tom Ellis, in a speech to the Cymmrodorion Society in 1897, stressed concomitant circumstances:

> But, perhaps, national and municipal galleries are not the main thing necessary for the cultivation among the Welsh people themselves of a sense and capacity for art. I think it quite possible that both in England and in Wales we have at the same time the production of hundreds and thousands of paintings or pictures, and yet a deterioration of the public taste and artistic taste. I think this is largely due to the fact that art and artists on the one hand, and ordinary life and industry on the other hand, have during the last century and a half been more and more divorced.[10]

Drawing heavily on William Morris's (1835–96) polemic against mass production, Ellis argued that this divorce was a consequence of the rampant industrial revolution during the eighteenth and nineteenth centuries. The development of mechanization and factory systems meant that the everyday domestic artefacts once made by the hands of skilled artisans could be produced in quantity and more cheaply by machinery. Design became divorced from the making of objects and there developed a division of labour between artist and workman, art and industry. The design of articles became the exclusive province of the artist, the execution the sole task of the workman. Consequently the workman had no cause to use or develop thought and skills in the things he made. In this way, Ellis contended, the workmen in Wales were denied the opportunity to cultivate an interest in and a capacity for art.[11] The absence of these qualities, Cunllo Davies wrote, was responsible for the depravity in aesthetic taste reflected in the art in the working man's home in south Wales.

The cultivation of artistic taste and talent was frustrated further, in the opinion of Herkomer, Clarke, and Williams, by the poor standard of education in the too few schools of art and craft that might have fostered indigenous talent. This, as Herkomer pointed out, gave rise to a migration of aspiring individuals to the London schools, leaving only a small number to train and work in Wales. The absence of financial encouragement from the wealthier classes had also forced artists to pursue their profession outside Wales, most notably in England. Wales was a small country in size and population, and also relatively poor. Without financial incentive from within the principality, those who went away thought it best to stay away.

The absence of the necessary economic basis to cultivate the material arts of painting, sculpture, and architecture was also used to explain why the Welsh failed in these respects and succeeded in music and poetry. Thomas Henry Thomas reasoned that, unlike the artist, the poet needed little material and therefore little money to pursue his art. Had he sufficient talent, an ordinary education would be enough to equip him with the means of literary expression. The same rule applied in the case of the rhetorician, whose talents were aided by practical scholarships from the Nonconformist colleges, and who were assured of an outlet of expression in the Welsh pulpit. Though ordinary education counted little in the instruction of the musician, opportunities for developing his abilities were provided by church and chapel choirs. The eisteddfod provided a means of public exposure for both poet and musician, where the latter in particular could obtain aid for future study.[12]

Whereas, like Thomas, many writers explained the disparity in the nation's enthusiasm for art, literature, and music 'solely to want of suggestion, opportunity and encouragement',[13] Cunllo Davies ascribed the imbalance to racial characteristics also: 'Singing and poetry are the expression of the soul . . . They are beauty which is felt; and because we are a race sensitive to feeling, we are eminently successful in the culture of the arts of singing and poetry. Painting is the beautiful in line and feature; and because we are surrounded with such beauty from cradle to the grave, among our native hills and valleys, it possesses no fascination for us.'[14] Around the turn of the century, and at the height of a revival of national consciousness in Wales, the

racial traits or national character of the Welsh would be frequently appealed to as
evidence that they had the potential to succeed in art as they had in literature and
music; as being suggestive of the content and tenor that Welsh art might assume in
the future; and as further proof of the poor state of Welsh art, manifest, as Thomas
observed, in the absence of any 'artists who stand out from the ranks of British Art
as being Welsh, in the sense of representing those characteristics which are generally
attributed to the race'.[15]

Art and National Revival: The Nonconformist Response

During the period of national revival a number of Nonconformists made a
significant contribution to improving the state of art in Wales by educating the Welsh
in art, by creating opportunities and facilities for exhibiting and seeing art, and by
acquiring great art for the nation. The development of the visual arts was one aspect
of the cultural resurgence in Wales around the turn of the century. Initially, it took
the form of an enthusiasm for the language, literature, history, and folk customs of
Wales,[16] but in the latter part of the nineteenth century it widened to embrace
politics, music, and the visual arts.[17]

Nonconformity's contribution to this revival up to the mid-nineteenth century
was indirect, a by-product of its evangelistic and philanthropic labours rather than a
consequence of an interest in nationalism itself.[18] The denominations' indifference
to the revival of national culture during the eighteenth and early nineteenth centuries
was due largely to their concern with the spiritual and moral atrophy that had set in,
and their preoccupation with the redemption of the sinner's soul and its preparation
for heaven.[19] During the latter part of the nineteenth century, however,
Nonconformity began to show more enthusiasm for the nationalist enterprise.
Absorbing the national spirit of self-aggrandizement and self-consciousness, it
began to further the cause of Welsh nationalism in the denominational periodicals
and from the pulpit.[20]

The principal protagonist for the cultivation of the visual arts in Wales was Ellis.
His vision, one gathers from his public lectures, was fuelled as much by a desire that
Wales should have all the accoutrements of culture possessed by the smaller nations
of Europe as by a love of art for its own sake.[21] The absence in Wales of an
identifiable school of painting, sculpture, and architecture was an embarrassment, an
indication of cultural retardation which dented an otherwise resilient national ego.
Ellis can also be credited with initiating what can only be described as a desperate
attempt to present evidence that Wales possessed artistic capability and thus the
potential for the establishment of a national school. Richard Wilson (1714–82),
Edward Coley Burne-Jones (1833–98), John Gibson (1790–1866), William
Goscombe John, Owen Jones (1809–74), and Inigo Jones (1573–1652) were
commonly cited as proof of Wales's contribution to the British school.[22] The
connection of most of these artists, particularly Burne-Jones and Owen Jones, to

Wales was, however, very tenuous. It was an honourable but misguided attempt to relate Wales to artists of star quality in order to accrue artistic prestige to the principality by association.

Further efforts to present a sense of continuity and an historical account of Wales's visual heritage were made by Thomas Henry Thomas in an unpublished article written in 1905 and entitled 'Some Welsh Artists and their Works', and, more notably, by T. Mardy Rees, a Congregational minister from Neath, in *Welsh Painters, Engravers, Sculptors 1527–1911*, published in 1912. It was the first book to give Wales something approaching a national biography of its artists. Rees's intention in compiling this history was to persuade the Welsh people of his day that they were 'capable of great things in Art'.[23] By this means he sought to revitalize an interest and practice in the visual arts so that the Welsh should not have 'to complain of the absence of Art any longer in . . . [their] Welsh towns and villages'.[24]

One of the elements which contributed to the revival of cultural consciousness was the idea of Celticism. It set Wales within a global context and endowed her with an impressive national lineage supposedly stretching back to early biblical history. Ellis and Thomas recommended the preservation of the vestiges of village Celtic crosses, which were considered an 'instinctive' skill of the Welshman of the ninth to eleventh centuries.[25] The few examples of monumental works of art which Wales possessed would, they believed, provide models for art education out of which great masters in painting and sculpture and even a national school would emerge.[26] The influence of Celticism on art in Wales, it was thought, would be expressed in terms of either the illustration of Celtic mythology and stories, or certain traits in the Celtic temperament which would manifest themselves naturally in the artist's work. The geography of the Celtic temperament had been discerned and popularized chiefly by Matthew Arnold (1822–88). His eulogistic appraisal of Celticism in *On the Study of Celtic Literature* of 1867 was often reconstituted by Welsh writers. Ellis, in his address on Welsh architecture in 1896, provided a typical précis of Arnold's inventory of Celtic qualities. He honoured the Welsh for, among other things, 'their love of beauty in nature, in man, in song, in art, their spirituality, their turn for emotional religion, their inbred love for all that is sentimental, spiritual and poetic'.[27]

Not surprisingly, when Nonconformists spoke of a national art school they stressed the religious aspect of the Celtic spirit as the pre-eminent characteristic, what Ellis referred to as 'that spirituality, and that serious outlook upon the mystery of life and the mystery of death which characterise the Cymry'.[28] In a similar vein Iona Williams delivered an address on Welsh art to the Park Church Literary and Debating Society in 1904. A report was printed in the *South Wales Press*:

> Mr. Williams discussed the possibility of establishing a school of national art expressive of the qualities characteristic of the Welsh people. Foremost among these qualities he placed a religious instinct touched with imaginative power, as often manifested in the discourses of our preachers. These qualities, coupled with a characteristic love and quick perception of beauty in all its forms, justified one in

expecting as their outcome an art beautiful in itself, yet serving also to express lofty morals and spiritual ideas, as opposed to the empty prettiness which is often the outcome of the motto, 'Art for Art's sake'.[29]

Like Herkomer, Williams substantiated his conviction that the Welsh could succeed in visual art by an appeal to their reputation in other departments of culture, in this instance preaching and a sensitivity to beauty.[30] Two years later Thomas would forge the same connection between preaching and art, seeing both disciplines as essentially two manifestations of a common imaginative faculty. Due to the same lack of opportunities, education, and resources that Williams held responsible for the 'non-existence of a recognised school of Welsh art', he conjectured that 'many a potential painter or sculptor has been a bard or preacher'.[31] During the nineteenth century it was expected that a good preacher would possess, together with a sound grasp of Scripture and rhetorical eloquence, the power of pictorial representation. As one writer put it, he was looked to to provide 'the charms of . . . painting'.[32]

Williams had envisaged the national art as a religious art, specifically a visual sermon capable of edifying the soul and informing the conscience rather than merely pleasing the eye. It reflected a utilitarian view of art popular during the second half of the nineteenth century.[33] Williams considered G. F. Watts to be the artist whose work best exemplified this ideal. Watts's father was Welsh, which would have enabled Williams to invest the artist with a Celtic lineage and possibly a Celtic temperament too. Nonconformity's contribution to this national religious art, as Mardy Rees's book records, was in terms of those artists from the ranks of the denominations who dealt with religious and ethical themes in their work. Among them were the sculptors William Davies and Joseph Edwards (1814–82), the photographer John Thomas, and Thomas Henry Thomas.

William Davies, whom Mardy Rees described as 'a deeply religious man, Precentor and Deacon and Sunday School Teacher at the Charing Cross Chapel', was one of many Welsh artists who were forced to leave their country and train in London; in Davies's case, at the studios of leading sculptors.[34] His 'religious' work consisted in sculpted busts of many Welsh preachers together with a number of statues, including the memorial to Thomas Charles. He also designed medallions for celebrated musicians, bards, and members of the wealthier classes. Between the years 1851 and 1888 Davies exhibited forty works at the Royal Academy.[35] Among his exhibits were busts of the notable Calvinistic Methodist ministers John Mills (1812–73), Henry Rees (1798–1869), and Lewis Edwards.

Like Thomas Henry Thomas and Mardy Rees, Davies also contributed to the development of a biographical account of Welsh artists. In 1895 he published an eight-part series on fellow Nonconformist and sculptor Joseph Edwards in the magazine *Wales*.[36] Both Davies and Edwards had begun their artistic training proper on leaving Wales for London and the studio of sculptor William Behnes (d.1864). Davies secured a position with Behnes, but Edwards did not. Edwards, however, was fortunate to obtain an engagement as a stonemason with a worker in marble. In 1837

Edwards entered the Royal Academy, where he proved to be an outstanding student, winning many medals, and where during the period 1838–78 he exhibited seventy works.[37] Much of Edwards's patronage came from gentry in England, although he also provided busts and statues for the gentry in Wales. The commissioned works were intended as monuments and depicted the Christian ideals close to Edwards's heart.[38] Among the statues illustrative of this ideal were *The Last Dream, Religion and Justice, Hope*, and *A Vision*; all of which works were highly commended in the *Art Journal*, and many were popularized as engravings by Richard Austin Arlett (1807–73), a notable engraver of sculptures.[39]

One Welsh artist and Nonconformist who lay outside the scope of Mardy Rees's biography was the photographer John Thomas. The title 'artist' is no misnomer; his self-estimate reflected his high view of the status of the photographer and the importance of taking photographs, which he believed to be an 'artistic experience'.[40] Together with raising the standard and medium of photography to the level of art, his major contribution was as a documentalist of late-nineteenth-century Wales. During his lifetime Thomas set about recording its famous personalities, architecture, monuments, and landscape. Like that of William Davies, the religious content of John Thomas's work often resides in the depiction of persons and artefacts associated with Nonconformity. His collection of photographs, at the National Library of Wales, includes missionaries and eminent Welsh preachers of his day, together with bards, poets, singers, and musicians. Thomas was probably the first photographer in Wales to document Welsh chapels as a subject in their own right (**23**). His photographs depicted both the exterior and interior of buildings, the latter usually as the background for group portraits of ministers and deacons (**14**). Among the monuments Thomas photographed was William Davies's statue of Thomas Charles.

Unlike William Davies, Thomas Henry Thomas returned to his native country after his training in London and settled in Cardiff. As an artist, Thomas was known chiefly as an illustrator of Welsh life, folklore, and natural history. During the early part of his career he also made a number of religious works including paintings and drawings of Old and New Testament characters copied from the works of nineteenth-century artists. He made a substantial contribution to the cultural life of Wales, lectured on art in schools in London and institutes throughout the country, and wrote many articles on ancient and modern art. Thomas was also instrumental in establishing the National Museum of Wales, and was chairman of the National Committee of Welsh Emblems. Moreover, he became one of the first promoters of the Royal Cambrian Society of Art, a national institution set up to promote and encourage the interests of the visual arts in Wales, and to provide a venue for an annual exhibition of artists' works.[41]

Besides the endeavours of Thomas Henry Thomas, Nonconformity's most significant contribution to the acquisition and appreciation of art in Wales was made by two Calvinistic Methodists, Gwendoline and Margaret Davies (1882–1951; 1884–1963) of Gregynog, near Newtown. From 1908 to 1924 the sisters jointly built

up a substantial collection of art, consisting primarily of nineteenth-century French painting, including works by Impressionist and Post-Impressionist painters and works from other schools and periods. Gwendoline and Margaret Davies bequeathed these works of art to the National Museum of Wales in 1952 and 1963 respectively and, as Douglas A. Basset has remarked, they 'enhanced the standing of the Museum collection almost beyond recognition'.[42] To some extent, the collection reflected the sisters' religious convictions and included works whose subjects either referred directly to or alluded to biblical themes. Among these are an allegorical painting by Jean-François Millet (1814–75) entitled *The Good Samaritan* (1846) and another entitled *The Sower* (1847–8), and sculptures by Auguste Rodin (1840–1917) representing biblical characters, *John the Baptist* (1878) and *Eve* (1881), and a Symbolist interpretation of the fall of Satan, *Illusions Fallen to the Earth* (1895). The Davies sisters' collection enabled Wales to possess great art again, which provided an incentive to art enthusiasm for lack of which their Calvinistic forebears had been blamed.

If, as Clarke and Williams argued, the lack of enthusiasm for art among the Welsh was a consequence of the dispossession of art, then to this extent Calvinism, as interpreted by the Puritan iconoclasts, can be held responsible for contributing to the retarded development of art in Wales. However, the blame for the poverty of Wales's visual culture cannot be placed at the door of the Protestant Reformers only. Adverse educational, economic, and institutional determinants played a significant part also, conditions which individual Nonconformists both recognized and actively sought to improve by the cultivation and pursuit of art. This invalidates the views of certain writers at the beginning of the twentieth century who, believing that Nonconformity had done nothing but retard the development of Wales's visual culture and the aesthetic taste of its people, made it the scapegoat for these deficiencies.

Conclusion

Nonconformity's contribution to Welsh culture has invariably been assessed in terms of the choral traditions of the chapel choirs, the temperance movements, and the provision of formal education through the Sunday Schools. Its contribution to the visual aspect of that culture has, for the most part, been disparaged, ignored, or overlooked. Such an attitude is unjustified, for while Nonconformity neither produced a school of art nor inspired a great movement in painting and sculpture, it nevertheless employed an enormous variety of visual artefacts in the service of religion. These artefacts, collectively, constitute a significant proportion of Wales's visual output during the nineteenth and early twentieth centuries, and as such represent not only the visual expression of Nonconformity, but also that of Wales in general.

The conscription of religious paraphernalia increased substantially after the mid-nineteenth century during the period of Nonconformity's aggrandizement. At this time, the building and adaptation of chapels ceased to be the work of the congregation and became instead the province of the professional architect and craftsman. Similarly, the requirements of decoration, commemoration, and teaching were no longer met by home-spun efforts but served by a veritable industry of commercial religious suppliers. Thus, the period marked the transition of Nonconformity from a self-sufficient community into an acquisitive consumer culture.

The use of these artefacts was often at variance with the Calvinistic view of art and religion. The profusion of imagery produced, commissioned, and adopted by Nonconformity was thus, to some extent, a consequence of doctrinal dissent. This dissent was not a deliberate rejection of Reformation teaching, but the cumulative consequence of a number of minor concessions, most notably the installation of such imagery, together with innocuous pictures and decorations, in places of worship. While Calvinism restricted the range and use of these artefacts in worship, it condemned neither art *per se* nor an active involvement in it. That so few Nonconformists participated in the visual culture of Wales during the nineteenth century may simply have been for lack of opportunity, encouragement, and suggestion. Those who did played an important role in both addressing the problem of Wales's deficiency in art and seeking to stimulate a love of art and aesthetic taste in the Welsh people.

The visual culture of Nonconformity reflected both the period style and the conventions of the nineteenth century, and in some instances, when the imagery and

symbolism of Catholicism were used, the traditions of Christian art in general. In these ways the visual expression of Nonconformity was inextricably linked to its age, to the history of art in general, and to religious iconography in particular. It is perhaps strange to use the phrase 'religious iconography' in connection with Nonconformist visual imagery, but it is valid to do so, for although in many instances these images were no more than ephemeral they were nevertheless the pictorial embodiment of Christian concepts, ideals, and values. Endowed with such attributes, these images became agents for transmitting Nonconformist ideology, in both chapel and home and to those outside the umbrella of Nonconformity. Thus the art of piety was made for utility, a means to an end and not an end in itself.

Notes

Introduction

1 Viator Cambrensis, *The Rise and Decline of Welsh Nonconformity: An Impartial Investigation* (London: I. Pitman, 1912), 54.

Chapter 1

1 Edmund Tyrrell-Green, *Art and Religion* (Lampeter: D. R. Evans, 1922), 3.
2 Anthony Jones, *Welsh Chapels* (Cardiff: National Museum of Wales, 1984), 2.
3 John Calvin, *Institutes of the Christian Religion*, translated by Henry Beveridge, 3 vols. (Edinburgh: Calvin Translation Society, 1845), I, 120–1.
4 Ibid., 125.
5 Ibid., 127.
6 Henry Bettenson (sel. and ed.), *Documents of the Christian Church* (Oxford: Oxford University Press, 1943, second edition 1967), 94.
7 Calvin, *Institutes*, I, 133.
8 Ibid.
9 Ibid.
10 Ibid., 135.
11 Ibid., 134.
12 E. T. Davies, 'The Church in Wales in 18th Century', in *Cyngres yr Eglwys yng Nghymru/Welsh Church Congress 1953*, lectures delivered at the Congress (1953), 53.
13 Thomas Rees, *History of Protestant Nonconformity in Wales*, second edition (London: John Snow, 1883), 454–5.
14 Ronald P. Jones, *Nonconformist Church Architecture* (London: Lindsey Press, 1914), 44.
15 Thomas Rees, op. cit., 454–5.
16 T. M. Bassett, *The Welsh Baptists* (Swansea: Ilston House, 1977), 242–3.
17 Charles Haddon Spurgeon, *Twelve Sermons on Prayer* (Grand Rapids, Michigan: Baker Book House, 1971), 100.
18 A. Morris, *History of Havelock Street, Presbyterian Church, Newport, Mon., Jubilee Souvenir, 1846–1914* (Newport: W. Jones, 1914), 20.
19 M. S. Briggs, *Puritan Architecture and its Future* (London and Redhill: Lutterworth Press, 1946), 64.
20 Communion tables and pulpits were supplied by church furnishers such as Geo. M. Hammer and Company, and J. Wippell and Company, both of London, and West and

Collier Limited, of Henley-on-Thames. Their advertisements appeared in the yearbooks and magazines of the English and Welsh denominational unions. Congregations could choose from a variety of designs illustrated in the furnishers' catalogues.

21 Both the copper-lustre and image-bearing cups were probably made by the Staffordshire potteries at the beginning of the eighteenth century. The former, writes Griselda Lewis, were 'widely used by Baptist chapels in Wales' (Griselda Lewis, *The Collector's History of English Pottery*, 1969 (Woodbridge, Suffolk: Antique Collector's Club, fourth revised edition 1987), 163).

22 Ronald P. Jones, op. cit., 44.

23 Ibid., 52–3.

24 Briggs, op. cit., 75.

25 The names of local painters, decorators, and stencillers appeared in trade directories for Wales such as *Pigot's Directory of Monmouthshire*, *Webster's Directory of Bristol and County of Glamorgan*, and *Worrell's Directory of South Wales.*

26 Books detailing the history of individual chapels (see Chapter 3) do not record the particulars of interior decoration; one assumes that stencilling and other forms of decorative painting (such as the painted texts mentioned below) are covered by the description 'painting'/'*peintio*' used in the inventories of expenses incurred in building or refurbishing chapels. (See, for example, William Joseph Rhys, *Braslun o Hanes Eglwys Caersalem Ystalyfera 1855–1955* (Swansea: Gwasg Clydach, [1955]), 9.) The names of the decorators employed to paint the chapels are rarely mentioned. Two instances are of Wallace Jones, painter, who in 1895 was hired to carry out renovations to the Baptist Church, Abercarn, Monmouthshire and W. E. Edmunds of Risca, Monmouthshire who was engaged to paint the interior of the same chapel and its schoolroom in 1915 (Rex H. Pugh, *A History of the Baptist Church, Abercarn* (Newport: R. H. Johns, 'Directory' Press, 1932), 74–5, 93).

27 Kenneth Lindley, *Chapels and Meeting Houses* (London: J. Baker, 1969), 38.

28 Scott-Mitchell writes: 'Lettering is usually charged at set rates *per inch*, measuring only the height of the letters . . . Fancy lettering, with many flourishes, such as "Old English" and flourished "script" types may be charged at rates varying from one-fourth to one-half higher than ordinary types . . . Lettering supported by considerable ornamental decoration, such as fancy initials and business advertisements, should be quoted to sketches supplied . . . Borders and lines surrounding lettering such as forming ribbons enclosing certain details, or stencilled ornaments, may be specified where thought advisable, and an outline sketch be required showing the position and extent of these details' (Frederick Scott-Mitchell, *Specifications for Decorators' Work*, 'The Decorator' Series of Practical Books, no. 5 (London: The Trade Papers Publishing Company, 1908), 57–8).

29 Viator Cambrensis, *The Rise and Decline of Welsh Nonconformity: An Impartial Investigation* (London: I. Pitman, 1912), 54.

30 The *Congregational Year Book* contained architectural descriptions and drawings of chapels built in any one year, and included details of their stained-glass windows.

The book would have been a significant means of informing congregations proposing to build a new or to improve an existing building about contemporary styles of chapel architecture and stained-glass windows, and the names of the church furnishers who supplied the windows.

31 The church also commissioned a painted panel from the same company who had executed the window. This portrayed the Sermon on the Mount in the centre, with four Evangelists on either side (**12**). In this image Christ was literally represented, with a halo ([Congregational Union of England and Wales], *Congregational Year Book* (London: Congregational Union of England and Wales, Unwin Brothers, 1905), 139).

32 Calvin, *Institutes*, I, 133.

33 John F. Sullivan, *The Externals of the Catholic Church* (London: Longmans, Green, 1955), 284.

34 [Calvinistic Methodist Church], *Cylchgrawn Cymdeithas Hanes y Methodistiaid Calfinaidd*, 2, journal 1 (September 1916), frontispiece.

35 Calvin, *Institutes*, I, 122.

36 [Baptist Union of England and Wales], *Baptist Handbook 1909* (London: Baptist Union Publications Department, 1909), p. viii. From the latter part of the nineteenth century Tutill traded across the board of denominations via their year-books, magazines, and journals. His advertments usually featured a drawing of one of the many banners contained in an illustrated catalogue which he dispatched to prospective customers.

37 C. R. Williams, 'The Welsh Revival, 1904–5', *British Journal of Sociology*, 3, no. 3 (September 1952), 242–59 (246).

38 *South Wales Daily News* (30 January 1905), 5.

39 Glanmor Williams, 'The Idea of Nationality in Wales', *Cambridge Journal*, 7, no. 3 (December 1953), 145–58 (157).

Chapter 2

1 Matthew Henry, *A Church in the House: A Sermon concerning Family-Religion* (London: Thomas Parkhurst, 1704), 11–13.

2 Ibid., 7.

3 Ibid., 11–13.

4 Matthew Henry, *An Exposition on the Old and New Testaments*, 3 vols. (London: Illustrated Bible and Commentary Warehouse; Partridge, Oakey, and Company, [1854]), II, 1160.

5 Henry, *A Church in the House*, 11–13.

6 Griselda Lewis, *The Collector's History of English Pottery*, 1969 (Woodbridge, Suffolk: Antique Collector's Club, fourth revised edition 1987), 165.

7 In 1866 an English-speaking chapel (Park Congregational Church) was constituted to meet the spiritual needs of the Staffordshire families who had come into the area (Gareth Hughes and Robert Pugh, *Llanelly Pottery* (Llanelli: Llanelli Borough

Council/Llanelli Public Library, 1990), 64). The growth of religious pottery at Llanelli subsequent to their arrival may have been an expression of the Wesleyan revivalist spirit that the potters had brought with them.

8 Samplers were also used to commemorate family occasions like births, marriages, and deaths, in which case the title of the event, its date, and the persons concerned are the dominant elements in the design. In all the samplers the name and age of the person who worked it and the year of its execution are embroidered at the bottom (F. G. Payne, *Samplers and Embroideries: A Handbook to a Temporary Exhibition, 12th December 1938–2nd April 1939* (Cardiff: National Museum of Wales, 1938), 4).

9 Dylan Thomas, *Under Milk Wood* (London: Dent, 1954, reprinted 1975), 43.

10 Henry, *An Exposition*, I, 378.

11 Henry, *A Church in the House*, 11–13.

12 Barbara Morris, *Victorian Embroidery* (London: Herbert Jenkins, 1962), 19.

13 Advertisements for Berlin wool-work appeared in the *Illustrated London News*. The biblical pictures were also promoted by the Great Exhibition of 1851 where, Morris writes, 'No less than six Berlin wool-work pictures after Leonardo da Vinci's celebrated "Last Supper" were shown' (ibid., 20, 23).

14 D. Cunllo Davies, 'Art in Welsh Homes', *Wales*, 2, no. 13 (May 1895), 223–4 (223).

15 Ibid., 224.

16 Ibid., 223.

17 Ibid., 224.

18 The portraits were engraved by English and Welsh artists and reproduced by printers and publishers of books mainly in London, Liverpool, Manchester, and Chester. William Mackenzie, a notable nineteenth-century publisher who was also responsible for printing several editions of illustrated family Bibles, produced prints of a great many famous Baptist, Calvinistic Methodist, and Independent Welsh preachers. Mackenzie's company was represented in London, Edinburgh, and Glasgow, as well as Swansea and Caerleon where the engravings of Welsh preachers were probably produced and disseminated. Printers and publishers in Liverpool and London would have catered as much for the large migrant communities of Welsh Nonconformists in those cities as for the sizeable market in Wales. Welsh book printers often produced images of worthies associated with the town or locality in which they were situated. For example, R. Saunderson of Bala printed not only the books but also engravings of Thomas Charles, the town's most notable religious leader.

19 Cunllo Davies, 'Art in Welsh Homes', 224.

20 Ibid.

21 [Postcard], *Salem* (Bristol: Harvey Barton, [n.d.]), no. 95.

22 Henry, *A Church in the House*, 54.

23 Martin Luther, 'Against the Heavenly Prophets in the Matter of Images and Sacraments', *Luther's Works* (55 vols.), edited by Conrad Bergendoff, Church and Ministry, 40 (Philadelphia: Muhlenberg Press, II, 1958), 99.

Chapter 3

1 Alan Bartram, *Lettering in Architecture* (London: Lund Humphries, 1975), 73–115.

2 Martin Luther, 'Against the Heavenly Prophets in the Matter of Images and Sacraments', *Luther's Works* (55 vols.), edited by Conrad Bergendoff, Church and Ministry, 40 (Philadelphia: Muhlenberg Press, II, 1958), 86.

3 Ibid., 88.

4 John Calvin, *Institutes of the Christian Religion*, translated by Henry Beveridge, 3 vols. (Edinburgh: Calvin Translation Society, 1845), I, 127.

5 Ibid., 128.

6 John Calvin, *The Second Epistle of Paul the Apostle to the Corinthians and the Epistle to Timothy, Titus, and Philemon*, Calvin's Commentaries, edited by David W. Torrance and Thomas F. Torrance, translated by T. A. Smail (Edinburgh: Oliver and Boyd, 1964), 261–2.

7 Matthew Henry, *An Exposition on the Old and New Testaments*, 3 vols. (London: Illustrated Bible and Commentary Warehouse; Partridge, Oakey, and Company, [1854]), III, 896.

8 For example, the statue to Thomas Charles, discussed below, cost £650, whereas Calvary English Baptist, Treforest, erected in 1851, cost £1,000; Tabernacle English Congregational Chapel, Aberdare, erected in 1855, cost £823; and Hundleton Calvinistic Methodist Church, Pembrokeshire, erected in 1879, cost £750 (E. T. Jenkins et al., *Calvary English Baptist Church Treforest: Historical Outline 1849–1949* (London: Kingsgate, 1949), 7; D. M. Richards, *The History of Tabernacle English Congregational Church Aberdare* (Aberdare: W. Lloyd and Son, 1893), 5; William Evans and Oscar S. Symond, *The History of South Pembrokeshire Calvinistic Methodist Churches* (Wrexham: Hughes and Son, 1913), 27).

9 D. E. Jenkins, *Rev. Thomas Charles of Bala*, 3 vols. (Denbigh: Llewelyn Jenkins, III, 1908, second edition 1910), 398. A proposal that a monument be set up in memory of Charles was carried at the meeting of the East Merionethshire presbytery in 1866. In 1867 a committee was established to commission designs for the statue and to obtain an estimate of the cost. A further committee was set up to raise money for its execution. This committee recommended that a collection be made from the Sunday Schools and churches of north and south Wales, and that additional support be requested from Methodists in the United States of America (ibid., 600).

10 [Calvinistic Methodist Church], 'Cofadail i Daniel Rowland, Llangeitho', *Drysorfa*, 206, no. 18 (February 1864), 75–6 (75).

11 The statue was paid for by subscriptions from Sunday School children, amounting to £114, with nearly £60 'from the memoir of the late Rowland by Morris Davies, as prizes to each one who collected a pound and over. £109 was collected by 15 young ladies who attempted to collect £5 each . . . Mr Davies, Llandinam according to his customary generosity, gave £50. The statue was £70 or £80 more than the original intention but it was judged that it was better to increase the costs than do anything that was unworthy of Daniel Rowland. At the beginning of this year £100 was

needed to complete the costs. It was decided to publish a small picture of the memorial and sell it for a shilling (**24**). The best bargain possible was struck for over two and a half thousand of these. Nearly £25 was paid for them.' ([Calvinistic Methodist Church], 'Daniel Rowland, Llangeitho', *Trysorfa y Plant* (Treffynnon: P. M. Evans, 1883), 282–7 (285, 286–7)).

12 Ibid., 286–7.

13 Ibid., 287.

14 [Wesleyan Methodist Church], *Proceedings of the Wesley Historical Society* (Burnley: Ashworth Nutall, VI, 1903), 19.

15 [Calvinistic Methodist Church], 'Daniel Rowland, Llangeitho', 287.

16 D. E. Jenkins, op. cit., III, 600.

17 J. Jones and J. Jones, 'Welsh Preaching', *Red Dragon*, 2 (1895), 428–36.

18 John Hughes, 'Lewis Edwards of Bala: His Influence upon the National Life of Wales', *Wales*, 1 (May–December 1911), 177–9 (177).

19 [Anon.], 'Welsh Holiday Resorts, 1. Pwllheli', *Wales*, 2, no. 13 (May 1895), 209–13 (211).

20 Thomas Jones, *Rhymney Memories* (Llandysul: Gomer Press, reprinted 1970), 137–8.

21 Thomas Charles, *An Exposition of the Ten Commandments by Way of Question and Answer* (Bala: R. Saunderson, 1805), 19.

22 T. Mardy Rees, *Welsh Painters, Engravers, Sculptors 1527–1911* (Caernarfon: Welsh Publishing Company, 1912), 69–70.

23 Balston cites the view of a Miss Dorothy Hartley of Llangollen who considered that during the mid-nineteenth century the figurines of Evans and Elias may have been brought from Staffordshire to north Wales along the old pack-horse routes which connected the two areas, and sold at local markets (Thomas Balston, *Staffordshire Portrait Figures of the Victorian Age* (London: Faber, 1958), 27–8). Since former Staffordshire potters worked at the Llanelli potteries during the mid-nineteenth century, it is possible that the figurines may also have been made there. Certainly, a bust of John Wesley was made by a south Wales pottery. It was poached from a design by Enoch Wood, a sculptor and potter working for the potteries in Staffordshire. Hughes and Pugh consider that while Wesley had strong connections with Llanelli, the bust may have been an experiment (Gareth Hughes and Robert Pugh, *Llanelly Pottery* (Llanelli: Llanelli Borough Council/Llanelli Public Library, 1990), 107; Roger Lee, *Wesleyana and Methodist Pottery: A Short Guide* (London: Lee, 1988), 11).

24 Horace Hird, 'A New Attribution for a Pottery Figure (John Bryan)', *Wesley Historical Society Proceedings*, 34, no. 4 (December 1963), 87–8 (88).

25 Ibid., 87.

26 John Ingamells, 'Painting in Wales 1550–1850', in Eric Rowan (ed.), *Art in Wales: 2000 BC–AD 1850* (Cardiff: University of Wales Press, 1978), 99–116 (106).

27 [Anon.], 'Current Notes', *Bye-gones, relating to Wales and the Border Counties*, second series, 6 (December 1899), 259.

28 Directories of trade for the second half of the nineteenth century indicate that

some of the major towns in Wales had up to four portrait painters. See, for example, *Pigot's Directory of Monmouthshire 1835* (Monmouth: Brian Stevens Historic Prints, 1972).

29 After the 1860s the directories show a marked decline in portrait painters and a disproportionate increase in portrait photographers of whom A. and G. Taylor of Cardiff was one. Suppliers of an 'Artistic and Pleasing Portrait' photograph, they also advertised in *The Baptist Chronicle* around 1894.

30 Hilary Woollen and Alistair Crawford, *John Thomas 1838–1905: Photographer* (Llandysul: Gomer Press, 1977), 22.

31 Illuminated addresses were supplied by local businesses such as Charles J. Protheroe of Pontypool, Monmouthshire, whose advertisement appeared in *The Baptist Chronicle* for 1894. Specimens were sent to potential customers on application.

32 A. Morris, *History of Havelock Street, Presbyterian Church, Newport, Mon., Jubilee Souvenir, 1846–1914* (Newport: W. Jones, 1914), 77.

33 The technique of transfer printing on to pottery was first used by the Staffordshire potteries in the mid-eighteenth century, but also began to be employed in Wales by the Cambrian and Glamorgan potteries during the late eighteenth century. The Llanelli potteries produced crockery by this means bearing the name of the chapel surrounded by a decorative embellishment such as an unfurled scroll or ribbon (Hugh Wakefield, *Victorian Pottery*, The Victorian Collector Series (London: Herbert Jenkins, 1962), 17; Kildare S. Meagre, *The Swansea and Nantgarw Potteries* (Swansea: Swansea Corporation, 1949), 6; Hughes and Pugh, op. cit., [201]).

34 John May and Jennifer May, *Commemorative Pottery 1790–1900* (London: Heinemann, 1972), 1.

35 *Y Goleuad* (4 September 1912), 8.

36 [Baptist Church], *A Confession of Faith Put Forth by the Elders and Brethren of Many Congregations of Christians (Baptized upon Profession of their Faith) in London and the Country* (London, 1688), 38.

Chapter 4

1 David Davies, *Sacred Themes and Famous Paintings* (London: Alexander and Shepherd, 1885), 94–5.

2 Ibid., preface.

3 Ibid., 7.

4 Ibid., 39.

5 Ibid., 31.

6 Ibid., preface.

7 Evan Williams, 'Picture Talks to Boys and Girls. "Napoleon on the Bellerophon"', *Baptist Record*, 3, no. 25 (January 1915), 13.

8 This, together with his alterations to the text of the 1790 Bible, led to his expulsion from the Calvinistic Methodist ministry (John Ballinger, *The Bible in Wales* (London: H. Sotheran, 1906), 49).

9 David Davies, *Sacred Themes*, 94–5.

10 George Wells Ferguson, *Signs and Symbols in Christian Art*, second edition (Oxford: Oxford University Press, 1961), 178.

11 W. Williams wrote of the Peter Williams Bible mentioned earlier, that it was '*the* Family Bible of the Welsh People' (W. Williams, *Welsh Calvinistic Methodism: A Historical Sketch of the Presbyterian Church of Wales* (London: Presbyterian Church of England, second edition 1884), 145). Thus, the biblical illustrations contained in these editions alone would have had a considerable audience and influence in Wales.

12 John Calvin, *Institutes of the Christian Religion*, translated by Henry Beveridge, 3 vols. (Edinburgh: Calvin Translation Society, 1845), I, 133.

13 David Davies, *Bunyan's 'Pilgrim's Progress' as Re-told for the Young* (London: Simpkin Marshall, [n.d.]), preface.

14 R. G. Thomas, 'How Can We Make our Sunday Schools More Attractive?', *Baptist Record*, 4, no. 48 (December 1916), 3.

15 [Baptist Union of England and Wales], 'Eastern Valley Baptist Sunday School Union. "The Children's Era"', *Baptist Record*, 8, no. 90 (June 1920), 19.

16 John Adams, *Primer on Teaching with Special Reference to Sunday School Work* (Edinburgh: T. and T. Clark, 1903), 15, 26–7.

17 J. H. Saxton, 'Colour and the Child', *Baptist Record*, 11, no. 143 (May 1926), 1–2 (1–2).

18 [Calvinistic Methodist Church], 'Notes of the Month', *Treasury*, 1, no. 9 (September 1913), 1–2 (1).

19 Ibid.

20 The National Sunday School Union advertised its pictures as 'Beautifully produced by the three-colour process, from paintings by such well-known artists as E. Stuart Hardy, Alfred Pearse, Ambrose Dudley, and A. McDonald'. The advertisement appeared regularly in the *Baptist Record* during the first three decades of the twentieth century.

21 Thomas Jones, *Rhymney Memories*, 1938 (Llandysul: Gomer Press, reprinted 1970), 126.

22 J. Morgan Gibbon, 'Two Hundred and Fifty Years-On!', *Congregational Year Book* (1914), 38–51 (48).

23 C. W. Screech, 'What is Wrong with the Sunday School?', *Baptist Record*, 11, no. 141 (March 1926), 1–2 (1–2); A. Penry Williams, 'Swinging on the Gate', *Congregational Magazine*, 8, no. 1 (January 1926), 18–19 (19).

24 David Walters, 'Moderator's Corner', *Congregational Magazine*, 8, no. 11 (November 1926), pp. [i–iii] (p. [i]); John Williamson, 'Theological Changes over the Past Fifty Years', *Congregational Magazine*, 6, no. 4 (April 1924), pp. [i–ix].

Chapter 5

1 H. Idris Bell, 'The Church in Wales and Modern Welsh Cultural Life', *Cyngres yr Eglwys yng Nghymru/Welsh Church Congress 1953*, lectures delivered at the Congress (1953), 81; Lord Cledwyn of Penrhos, *Celfyddyd a'r Cymro Cyffredin/Art and the Average*

Welshman, Ben Bowen Thomas Lecture (North Wales Arts Association, 1979), [1].

2 Edmund Tyrrell-Green, *Art and Religion* (Lampeter: D. R. Evans, 1922), 6; Viator Cambrensis, *The Rise and Decline of Welsh Nonconformity: An Impartial Investigation* (London: I. Pitman, 1912), 54.

3 Tyrrell-Green, op. cit., 6.

4 From *Census of Great Britain 1851, Population Tables II*, vol. II (London: HMSO, 1854).

5 W. Llewelyn Williams, 'Tom Ellis. I', *Young Wales*, no. 52 (April 1899), 75–9 (75).

6 Hubert Herkomer, 'Welsh Art Culture', *Transactions of the Liverpool Welsh National Society*, session 12 (1896–7), 9–23; J. Clarke, 'Art in Wales', *Young Wales*, 1 (1895), 204–6 (204).

7 Ibid.; see also Glanmor Williams, *The Welsh Church from Conquest to Reformation* (Cardiff: University of Wales Press, 1962), 451.

8 Iona Williams, 'Welsh Art', *The Welsh Review*, 1, no. 5 (July 1906), 123.

9 Clarke, 'Art in Wales', 205; Iona Williams, 'Welsh Art', 123.

10 Thomas E. Ellis, 'Domestic and Decorative Art in Wales', *Transactions of the Honourable Society of Cymmrodorion* (session 1896–7), 14–33 (18).

11 Ibid., 18–19.

12 T. H. Thomas, 'Art in Wales', *Transactions of the Liverpool Welsh National Society*, session 23 (1906–7), 35–40 (35).

13 Cuthbert C. Grundy, 'Art in Wales', *Wales*, 6, no. 39 (July 1914), 229–32 (231).

14 D. Cunllo Davies, 'Art in Welsh Homes', *Wales*, 2, no. 13 (May 1895), 223–4 (223).

15 T. H. Thomas, 'Art in Wales', 35.

16 J. E. Lloyd, *A History of Wales* (London: Ernest Benn, 1930), 71–8; Glanmor Williams, 'The Idea of Nationality in Wales', *Cambridge Journal*, 7, no. 3 (December 1953), 145–58 (146).

17 G. Hartwell Jones, 'The Celtic Renaissance and How to Forward It', *Y Cymmrodor*, 42 (1930), 111–28 (113); A. O. H. Jarman, 'Wales a Part of England 1485–1800', in *The Historical Basis of Welsh Nationalism*, by A. W. Wade-Evans et al. (Cardiff: Plaid Cymru, 1950), 79–98 (98).

18 R. T. Jenkins, 'The Development of Nationalism in Wales', *Sociological Review*, 27 (1935), 163–82 (175).

19 Lloyd, op. cit., 54; Glanmor Williams, 'The Idea of Nationality in Wales', 149; R. T. Jenkins, 'The Development of Nationalism in Wales', 175. The pagan antecedents of the druidic aspect of this revival, and the association of the early eisteddfod meetings with the common ale-house further discouraged the Nonconformists' sense of pride in the past and any desire to participate in its rehabilitation (Lloyd, op. cit., 69). Prys Morgan believes that the Nonconformists identified their history more with the Old Testament than with the Welsh past (Prys Morgan, 'From a Death to a View: The Hunt for the Welsh Past in the Romantic Period', in *The Invention of Tradition*, edited by Eric Hobsbawm and Terence Ranger (Cambridge: Cambridge University Press, 1983), 43–100 (95)).

20 Glanmor Williams, 'The Idea of Nationality in Wales', 150.

21 Ellis, 'Domestic and Decorative Art in Wales', 15.

22 Isaac J. Williams, in 'The Teaching of Art and Architecture in Wales', *Transactions of the Honourable Society of Cymmrodorion* (session 1923–4), part 7, 61–115 (97); Ellis, 'Domestic and Decorative Art in Wales', 16.

23 T. Mardy Rees, *Welsh Painters, Engravers, Sculptors 1527–1911* (Caernarfon: Welsh Publishing Company, 1912), 3.

24 Ibid., 132.

25 Ellis, 'Domestic and Decorative Art in Wales', 18.

26 Ibid.; T. H. Thomas, 'Celtic Art, with a Suggestion of a Scheme for the Better Preservation and Freer Study of the Monuments of the Early Christian Church in Wales', *Y Cymmrodor*, 12 (1897), 87–111 (108).

27 Thomas E. Ellis, *Speeches and Addresses* (Wrexham: Hughes and Son, 1912), 92; see also Matthew Arnold, *On the Study of Celtic Literature* (London: Smith, Elder, and Company, 1867), 102–4.

28 Ellis, 'Domestic and Decorative Art in Wales', 33.

29 *South Wales Press* (3 November 1904), 8.

30 Herkomer, 'Welsh Art Culture', 9–23.

31 T. H. Thomas, 'Art in Wales', 36.

32 Edwin Paxton Hood, *Christmas Evans* (London: Hodder and Stoughton, 1881), 3.

33 Frederic Leighton, *Addresses Delivered to the Students of the Royal Academy* (London: Kegan Paul, Trench, Trübner, and Company, 1896), 39–40.

34 Mardy Rees, op. cit., 29.

35 Algernon Graves, *A Dictionary of Artists who have Exhibited Works in the Principal London Exhibitions from 1760 to 1893*, enlarged edition (London: H. Graces, 1895), 74.

36 William Davies, 'Joseph Edwards, Sculptor', *Wales*, 2, no. 12 (April 1895), 134–7; no. 13 (May 1895), 193–5; no. 14 (June 1895), 273–8; no. 15 (July 1895), 301–3; no. 16 (August 1895), 355–60; no. 17 (September 1895), 403–5; no. 18 (November 1895), 468–72; no. 19 (December 1895), 540–3.

37 Graves, op. cit., 89.

38 Charles Wilkins, 'Joseph Edwards, the Sculptor', *Red Dragon*, 1 (March 1882), 97–107 (103).

39 Mardy Rees, op. cit., 37.

40 Hilary Woollen and Alistair Crawford, *John Thomas 1838–1905: Photographer* (Llandysul: Gomer Press, 1977), 18.

41 Mardy Rees, op. cit., 132; John Ballinger, *Memoir: Thomas Henry Thomas R.C.A. (1839–1915)* (Cardiff: William Lewis, 1916), 11.

42 Peter Hughes, *French Art from the Davies Bequest* (Cardiff: National Museum of Wales, 1982), 2.

Select Bibliography

Dates enclosed within square brackets are not included in the books and periodicals themselves, but are derived from the catalogue of the National Library of Wales.

Adams, John, *Primer on Teaching with Special Reference to Sunday School Work* (Edinburgh: T. and T. Clark, 1903).

[Anon.], 'Current Notes', *Bye-gones, relating to Wales and the Border Counties*, second series, 6 (December 1899).

——,'Welsh Holiday Resorts, 1. Pwllheli', *Wales*, 2, no. 13 (May 1895), 209–13.

Arnold, Matthew, *On the Study of Celtic Literature* (London: Smith, Elder, and Company, 1867).

Ballinger, John, *The Bible in Wales* (London: H. Sotheran, 1906).

——, *Memoir: Thomas Henry Thomas R.C.A. (1839–1915)* (Cardiff: William Lewis, 1916).

Balston, Thomas, *Staffordshire Portrait Figures of the Victorian Age* (London: Faber, 1958).

[Baptist Church], *A Confession of Faith Put Forth by the Elders and Brethren of Many Congregations of Christians (Baptized upon Profession of their Faith) in London and the Country* (London, 1688).

——, *The Faithfulness of God: Bethel English Baptist Church, Maesteg, 1847–1947* (London: Kingsgate Press, 1947).

——, *Iwbili: Eglwys y Bedyddwr Brynhyfryd, Abertawe, 1881–1931* (Swansea: Trerise Agraffydd, 1931).

——, 'Pilgrim's Progress, Welsh and English', *Baptist Quarterly*, 1 (1922–33), 39–42.

[Baptist Union of England and Wales], *Baptist Handbook 1909* (London: Baptist Union Publications Department, 1909).

——, 'Eastern Valley Baptist Sunday School Union. "The Children's Era"', *Baptist Record*, 8, no. 90 (June 1920), 19.

Bartram, Alan, *Lettering in Architecture* (London: Lund Humphries, 1975).

Bassett, T. M., *The Welsh Baptists* (Swansea: Ilston House, 1977).

Bell, David, *The Artist in Wales* (London: Harrap, 1957).

Bell, H. Idris, 'The Church in Wales and Modern Welsh Cultural Life', *Cyngres yr Eglwys yng Nghymru/Welsh Church Congress 1953*, lectures delivered at the Congress (1953).

Bettenson, Henry (sel. and ed.), *Documents of the Christian Church* (Oxford: Oxford University Press, 1943, second edition 1967).

[Bible, English], *Imperial Family Bible* (London: Blackie, 1844).

[Bible, Welsh], *Y Bibl Teuluaidd Cynnwysfawr* (London: Blackie, [n.d.]).

[Bible, Welsh], *Y Bibl Teuluaidd Cynnwysfawr*, gyda sylwadau eglurhaol Peter Williams (London: Blackie, [n.d.]).

——, *Y Bibl Cyssegr-lan*, gyda sylwadau eglurhaol Peter Williams (Swansea: William Mackenzie, 1873).

——, *Y Bibl Cyssegr-lan*, gyda nodiadau eglurhaol gan Peter Williams a Matthew Henry (Edinburgh: Thomas C. Jack; Cardiff: W. Berry, [1874]).

——, *Bibl yr Addoliad Teuluaidd*, gyda sylwadau eglurhaol Peter Williams (Porth: Jones and Jones, [1895]).

——, *Bibl yr Addoliad Teuluaidd*, gyda sylwadau eglurhaol Peter Williams (London: London Printing and Publishing Company, [n.d.]).

——, *Bibl yr Addoliad Teuluaidd*, gyda sylwadau eglurhaol Peter Williams (Bristol: R. Reid, [n.d.]).

Bransby, James Hews, *An Account of the Calvinistic Methodists in Wales, their Origin, History and Present State* (Caernarfon: James Rees, 1845).

Briggs, M. S., *Puritan Architecture and its Future* (London and Redhill: Lutterworth Press, 1946).

Bunyan, John, *Taith y Pererin* ['Pilgrim's Progress'] (London: Henry Fisher, 1819, second edition 1824, third edition 1827, fourth edition 1832).

——, *Taith y Pererin* (Caerleon: T. Thomas, 1842).

——, *Taith y Pererin* (Caernarfon: L. E. Jones, 1821, second edition 1833, reissued H. Humphreys, 1848).

——, *Taith y Pererin* (Bala: G. Jones, 1856).

——, *Taith y Pererin* (Denbigh: Thomas Gee, 1860, reprinted 1904).

——, *Taith y Pererin* (Caernarfon: H. Humphreys, 1861).

——, *Taith y Pererin* (London: James S. Virtue, 1867).

——, *Taith y Pererin* (Edinburgh: Thomas C. Jack, 1876, reprinted 1885).

Calvin, John, *Institutes of the Christian Religion*, translated by Henry Beveridge, 3 vols. (Edinburgh: Calvin Translation Society, 1845).

——, *The Second Epistle of Paul the Apostle to the Corinthians and the Epistle to Timothy, Titus, and Philemon*, Calvin's Commentaries, edited by David W. Torrance and Thomas F. Torrance, translated by T. A. Smail (Edinburgh: Oliver and Boyd, 1964).

[Calvinistic Methodist Church], *An Address from the Ministers of the Calvinistic Methodist Church, to Mrs Elizabeth Davies J.P., Miss Gwendoline Elizabeth Davies, and Miss Margaret Sidney Davies, of Plas-Dinam* (Gregynog: Gwasg Gregynog, 1921).

——, 'Cofadail i Daniel Rowland, Llangeitho', *Drysorfa*, 206, no. 18 (February 1864), 75–6.

——, *Cyfarfodydd Dathlu Dau Can Mlwyddiant Cychwyn Methodistiaeth yng Nghaerfyrddin, Eglwys Bresbyteriaidd Cymru (Y Methodistiaid Calfinaidd)*, Tachwedd 6–10 (1938).

——, *Cylchgrawn Cymdeithas Hanes y Methodistiaid Calfinaidd*, 1–3 (1916–18).

——, 'Daniel Rowland, Llangeitho', *Drysorfa*, 636, no. 53 (October 1883), 394–5.

——, 'Daniel Rowland, Llangeitho', *Trysorfa y Plant* (Treffynnon: P. M. Evans, 1883), 282–7.

——, 'Notes of the Month', *Treasury*, 1, no. 9 (September 1913), 1–2.

——, *Souvenir: Bethany Presbyterian Church, Bryncoe, Llanharan* (Birmingham: Bradmore, 1930).

——, *Trysorfa y Plant*, 1–32 (Treffynnon: P. M. Evans, 1862–93); 33–58 (Caernarfon: David O'Brien Owen, 1894–1919); 59–64 (Caernarfon: Lyfrafu'r Cyfundeb, 1920–5).

Cambrensis, Viator, *The Rise and Decline of Welsh Nonconformity: An Impartial Investigation* (London: I. Pitman, 1912).

[Census Returns], *Census of Great Britain 1851, Population Tables II*, vol. II (London: HMSO, 1854).

Charles, Thomas, *An Exposition of the Ten Commandments by Way of Question and Answer* (Bala: R. Saunderson, 1805).

——, *Geiriadur Ysgrythyrawl*, 4 vols. (Bala: R. Saunderson, 1819–25).

——, *Geiriadur Ysgrythyrawl* (Bala: R. Saunderson, 1864).

Clarke, J., 'Art in Wales', *Young Wales*, 1 (1895), 204–6.

Cledwyn of Penrhos, Lord, *Celfyddyd a'r Cymro Cyffredin/Art and the Average Welshman*, Ben Bowen Thomas Lecture (North Wales Arts Association, 1979).

[Congregational Church], *Eglwys Annibynnol Bethel Newydd Cwmamman, Addroddiad am y Flwyddyn, 1941* (Pontardawe: W. Pugh, 1941).

——, *Mount Pleasant Congregational Church, Pontypool, Bazaar Handbook* (Pontypool: Hughes, 1899).

[Congregational Union of England], *English Congregational Union of North Wales: Twenty-First Annual Report together with the Chairman's Address and Papers Read at the Assembly at Queen St. Church, Chester, April 18 and 19, 1898* (Chester: W. H. Evans, 1898).

[Congregational Union of England and Wales], *Congregational Year Book* (London: Congregational Union of England and Wales, Unwin Brothers, 1905).

Crouch, Joseph, *Puritanism and Art: An Enquiry into a Popular Fallacy* (London: Cassell, 1910).

Davies, David, *Bunyan's 'Pilgrim's Progress' as Re-told for the Young* (London: Simpkin Marshall, [n.d.]).

——, *Sacred Themes and Famous Paintings* (London: Alexander and Shepherd, 1885).

Davies, D. Cunllo, 'Art in Welsh Homes', *Wales*, 2, no. 13 (May 1895), 223–4.

——, *Hanes Eglwys Hermon, Dowlais* (Bala: Davies and Evans, 1905).

Davies, E. T., 'The Church in Wales in 18th Century', in *Cyngres yr Eglwys yng Nghymru/ Welsh Church Congress 1953*, lectures delivered at the Congress (1953).

Davies, William, 'Joseph Edwards, Sculptor', *Wales*, 2, no. 12 (April 1895), 134–7; no. 13 (May 1895), 193–5; no. 14 (June 1895), 273–8; no. 15 (July 1895), 301–3; no. 16 (August 1895), 355–60; no. 17 (September 1895), 403–5; no. 18 (November 1895), 468–72; no. 19 (December 1895), 540–3.

Edwards, R., *Bethania, Aberteifi* (Llandysul: Gwasg Gomer, 1947).

Ellis, Thomas E., 'Domestic and Decorative Art in Wales', *Transactions of the Honourable Society of Cymmrodorion* (session 1896–7), 14–33.

——, *Speeches and Addresses* (Wrexham: Hughes and Son, 1912).

Evans, W., *History of Welsh Theology* (London: J. Nisbet, 1900).

Evans, William and Oscar S. Symond, *The History of South Pembrokeshire Calvinistic Methodist Churches* (Wrexham: Hughes and Son, 1913).

Ferguson, George Wells, *Signs and Symbols in Christian Art,* second edition (Oxford: Oxford University Press, 1961).

Gibbon, J. Morgan, 'Two Hundred and Fifty Years-On!', *Congregational Year Book* (1914), 38–51.

Graves, Algernon, *A Dictionary of Artists who have Exhibited Works in the Principal London Exhibitions from 1760 to 1893*, enlarged edition (London: H. Graces, 1895).

Griffith, Edward, *Presbyterian Church of Wales (Calvinistic Methodists) Historical Handbook, 1735–1905* (Wrexham: Hughes and Son, 1905).

Grundy, Cuthbert C., 'Art in Wales', *Wales*, 6, no. 39 (July 1914), 229–32.

Henry, Matthew, *A Church in the House: A Sermon concerning Family-Religion* (London: Thomas Parkhurst, 1704).

——, *An Exposition on the Old and New Testaments*, 3 vols. (London: Illustrated Bible and Commentary Warehouse; Partridge, Oakey, and Company, [1854]).

Herkomer, Hubert, 'Welsh Art Culture', *Transactions of the Liverpool Welsh National Society*, session 12 (1896–7), 9–23.

Hird, Horace, 'A New Attribution for a Pottery Figure (John Bryan)', *Wesley Historical Society Proceedings*, 34, no. 4 (December 1963), 87–8.

Hood, Edwin Paxton, *Christmas Evans* (London: Hodder and Stoughton, 1881).

Hughes, Gareth and Robert Pugh, *Llanelly Pottery* (Llanelli: Llanelli Borough Council/ Llanelli Public Library, 1990).

Hughes, John, 'Lewis Edwards of Bala: His Influence upon the National Life of Wales', *Wales*, 1 (May–December 1911), 177–9.

Hughes, Peter, *French Art from the Davies Bequest* (Cardiff: National Museum of Wales, 1982).

Ingamells, John, 'Painting in Wales 1550–1850', in Eric Rowan (ed.), *Art in Wales: 2000 BC–AD 1850* (Cardiff: University of Wales Press, 1978), 99–116.

Jarman, A. O. H., 'Wales a Part of England 1485–1800', in *The Historical Basis of Welsh Nationalism*, by A. W. Wade-Evans et al. (Cardiff: Plaid Cymru, 1950), 79–98.

Jenkins, D. E., *Rev. Thomas Charles of Bala*, 3 vols. (Denbigh: Llewelyn Jenkins, 1908, second edition 1910).

Jenkins, E. T., et al., *Calvary English Baptist Church Treforest: Historical Outline 1849–1949* (London: Kingsgate, 1949).

Jenkins, R. T., 'The Development of Nationalism in Wales', *Sociological Review*, 27 (1935), 163–82.

Jones, Anthony, *Welsh Chapels* (Cardiff: National Museum of Wales, 1984).

Jones, G. Hartwell, 'The Celtic Renaissance and How to Forward It', *Y Cymmrodor*, 42 (1930), 111–28.

Jones, J. and J. Jones, 'Welsh Preaching', *Red Dragon*, 2 (1895), 428–36.

Jones, M. H., *Hanes Eglwys M.C., Jerusalem, Ton., 1920* (Ystrad: John Davies, 1920).

Jones, Ronald P., *Nonconformist Church Architecture* (London: Lindsey Press, 1914).

Jones, Thomas, *Rhymney Memories*, 1938 (Llandysul: Gomer Press, reprinted 1970).

Lee, Roger, *Wesleyana and Methodist Pottery: A Short Guide* (London: Lee, 1988).

Leighton, Frederic, *Addresses Delivered to the Students of the Royal Academy* (London: Kegan Paul, Trench, Trübner, and Company, 1896).

Lewis, Griselda, *The Collector's History of English Pottery*, 1969 (Woodbridge, Suffolk: Antique Collector's Club, fourth revised edition 1987).

Lindley, Kenneth, *Chapels and Meeting Houses* (London: J. Baker, 1969).

Lloyd, J. E., *A History of Wales* (London: Ernest Benn, 1930).

Luther, Martin, 'Against the Heavenly Prophets in the Matter of Images and Sacraments', *Luther's Works* (55 vols.), edited by Conrad Bergendoff, Church and Ministry, 40 (Philadelphia: Muhlenberg Press, II, 1958).

May, John and Jennifer May, *Commemorative Pottery 1790–1900* (London: Heinemann, 1972).

Meagre, Kildare S., *The Swansea and Nantgarw Potteries* (Swansea: Swansea Corporation, 1949).

Morgan, Prys, 'From a Death to a View: The Hunt for the Welsh Past in the Romantic Period', in *The Invention of Tradition*, edited by Eric Hobsbawm and Terence Ranger (Cambridge: Cambridge University Press, 1983), 43–100.

Morris, A., *History of Havelock Street, Presbyterian Church, Newport, Mon., Jubilee Souvenir, 1846–1914* (Newport: W. Jones, 1914).

——, *The Story of Ebenezer Church, Newport, Mon.* (Newport: W. Jones, 1916).

Morris, Barbara, *Victorian Embroidery* (London: Herbert Jenkins, 1962).

Morris, Caleb, *Braslun o Hanes Eglwys Annibynnol Ebenezer: Trefdraeth, Penfro 1700–1945* (Aberdare: Stephens and George, 1945).

Morris, William, *The Decorative Arts: Their Relation to Modern Life and Progress* (London: Ellis and White, [n.d.]).

Payne, F. G., *Samplers and Embroideries: A Handbook to a Temporary Exhibition, 12th December 1938–2nd April 1939* (Cardiff: National Museum of Wales, 1938).

Peters, John and Gweirydd ap Rhys, *Enwogion y Ffydd*, edited by John Peters and Gweirydd ap Rhys, 3 vols. (London: William Mackenzie, [n.d.]).

Price, Isaac, *Jubilee Eglwys y Bedyddwr ym Mrynhyfryd, Treharris* (Treharris: W. R. Davies, 1929).

Pugh, Rex H., *A History of the Baptist Church, Abercarn* (Newport: R. H. Johns, 'Directory' Press, 1932).

Rees, Thomas, *History of Protestant Nonconformity in Wales*, second edition (London: John Snow, 1883).

Rees, T. Mardy, *Welsh Painters, Engravers, Sculptors 1527–1911* (Caernarfon: Welsh Publishing Company, 1912).

Rhys, William Joseph, *Braslun o Hanes Eglwys Caersalem Ystalyfera 1855–1955* (Swansea: Gwasg Clydach, [1955]).

Richards, D. M., *The History of Tabernacle English Congregational Church Aberdare* (Aberdare: W. Lloyd and Son, 1893).

Saxton, J. H., 'Colour and the Child', *Baptist Record*, 11, no. 143 (May 1926), 1–2.

Scott-Mitchell, Frederick, *Specifications for Decorators' Work*, 'The Decorator' Series of Practical Books, no. 5 (London: The Trade Papers Publishing Company, 1908).

Screech, C. W., 'What is Wrong with the Sunday School?', *Baptist Record*, 11, no. 141 (March 1926), 1–2.

Springer, Lynne E., 'Biblical Scenes in Embroidery', *Antiques*, 51, no. 2 (February 1972), 374–83.

Spurgeon, Charles Haddon, *Twelve Sermons on Prayer* (Grand Rapids, Michigan: Baker Book House, 1971).

Stephens, Tom, *History of Zion Baptist Church, Ponthir, Mon.* (Frome and London: Butler and Tanner, 1934).

Sullivan, John F., *The Externals of the Catholic Church* (London: Longmans, Green, 1955).

Thomas, R. G., 'How Can We Make our Sunday Schools More Attractive?', *Baptist Record*, 4, no. 48 (December 1916), 3.

Thomas, T. H., 'Art in Wales', *Transactions of the Liverpool Welsh National Society*, session 23 (1906–7), 35–40.

——, 'Celtic Art, with a Suggestion of a Scheme for the Better Preservation and Freer Study of the Monuments of the Early Christian Church in Wales', *Y Cymmrodor*, 12 (1897), 87–111.

Thompson, C., *Braslun Hanesyddawl o Enwad y Beddyddwr* (Bangor: Robert Jones, 1839).

Tyrrell-Green, Edmund, *Art and Religion* (Lampeter: D. R. Evans, 1922).

Wakefield, Hugh, *Victorian Pottery*, The Victorian Collector Series (London: Herbert Jenkins, 1962).

Walters, David, 'Moderator's Corner', *Congregational Magazine*, 8, no. 11 (November 1926), pp. [i–iii].

Wilkins, Charles, 'Joseph Edwards, the Sculptor', *Red Dragon*, 1 (March 1882), 97–107.

Williams, A. Penry, 'Swinging on the Gate', *Congregational Magazine*, 8, no. 1 (January 1926), 18–19.

Williams, C. R., 'The Welsh Revival, 1904–5', *British Journal of Sociology*, 3, no. 3 (September 1952), 242–59.

Williams, D. E., *Y Can Mlynedd Cipdrem a Hanes Eglwys Bryn Seion Cwmbach 1845–1945* (Aberdare: Stephens and George, [1945]).

Williams, Evan, 'Picture Talks to Boys and Girls. "Napoleon on the Bellerophon"', *Baptist Record*, 3, no. 25 (January 1915), 13.

Williams, Glanmor, 'The Idea of Nationality in Wales', *Cambridge Journal*, 7, no. 3 (December 1953), 145–58.

——, *The Welsh Church from Conquest to Reformation* (Cardiff: University of Wales Press, 1962).

Williams, Iona, 'Welsh Art', *The Welsh Review*, 1, no. 5 (July 1906), 123.

Williams, Isaac J., 'The Teaching of Art and Architecture in Wales', *Transactions of the Honourable Society of Cymmrodorion* (session 1923–4), part 7, 61–115.

Williams, J. Ronald and Gwyneth Williams, *History of Caersalem, Dowlais* (Llandysul: Gomer Press, 1967).

Williams, W., *Welsh Calvinistic Methodism: A Historical Sketch of the Presbyterian Church of Wales* (London: Presbyterian Church of England, second edition 1884).

Williams, W. Llewelyn, 'Tom Ellis. I', *Young Wales*, no. 52 (April 1899), 75–9.

Woollen, Hilary and Alistair Crawford, *John Thomas 1838–1905: Photographer* (Llandysul: Gomer Press, 1977).

Index

Page references in italic denote illustrations.